SPECIMEN COLONY

Alec Finlay

'where every tree is a probem to be solved by birdsong.'
—*Alice Oswald*

SPECIMEN COLONY

Six colonies for a European city

Alec Finlay
Alexander Maris
Andrew Morley
Iain Pate
Jo Salter

*Liverpool University Press in association
with platform projects & the Bluecoat*
2008

for Norma
for Tomble & Lisa
for Goose

ONE NEST AFTER ANOTHER

One nest rolls after another
Untill there are no longer any birds
One tounge lashes another
Untill ther are no longer any words[1]
— *Captain Beefheart (1972)*

Despite the cacophony of demolition and construction that the Bluecoat has witnessed as a building site over the past three years, for those for whom the building normally represents a hub of creativity in the heart of Liverpool, the absence of art represents an eerie quietude. The silence alluded to in the above poem is now however broken. With the approach of spring the birds are coming home to roost, searching for shelter, a place to nest, metaphorically but also in a real sense. For brightly coloured nest-boxes now colonise the branches of the trees in our garden.

In responding to a commission opportunity to create an artwork during the Bluecoat's closure for its building development, Alec Finlay, working in collaboration with two other artists Jo Salter and Andrew Morley, has produced *Specimen Colony*, a poetic meditation on dwelling and diaspora that adopts the familiar form of a nest-box. With its focus on colourful and exotic birds, their designs gleaned from myriad postage stamps from around the world, the work is also a mirror of the contemporary city with its hybrid, vibrant communities. The bird motif is particularly appropriate for Liverpool, a city whose symbol is a mythical bird, the Liver Bird, of which the Bluecoat, as the oldest city centre building, possesses on its façade arguably the oldest sculptural representations. And Liverpool's connections to the world through its history as a port, a place of departure and arrival witnessing movements of goods and peoples both into and from the city, provide added resonance to the theme of migration.

This project is presented as part of the Bluecoat's re-opening exhibition, *Now Then*, staged in Liverpool's year as European Capital of Culture, when the focus on identity – European, British, Liverpool's own cultural particularity – will address and unpack some of the myths and assumptions around how we, and others, see ourselves and where we live. Birds are particular to place. 2,400 species are illustrated on over 12,500 stamps issued by 350 countries, each representing a specific landscape or state. Distributed around the world, they become recognisable emblems of national identity. As symbols however, birds are also generic, universal, utopian even – the dove of peace, the phoenix rising from the ashes. Birds therefore transcend nationality. This duality of the particular and the universal is explored in *Specimen Colony*, not least in the way the eye for detail evident in the work's conception and production can be appreciated by the ornithologist and philatelist alike, whilst the exuberance

of the bird boxes, with their downloadable DIY cut-out versions, has a wider, more general appeal. This democratic capacity reflects the communicative function of stamps and the free flow of ideas that correspondence represents. Similarly stamp collecting has traditionally been one of the most popular ways through which people discover the world.

During *Now Then* the nest-boxes spread out from the indoor refuge of an installation in the elegant cloister than runs the length of the new gallery overlooking the re-landscaped garden, the conceptual starting point for *Specimen Colony*. Soon the indoor boxes will move to their permanent home in the trees at the front of the gallery. Designed by Rotterdam architects BIQ, this indoor space takes for its inspiration the contemplative interiors created by the architect and Dominican monk Hans van der Laan, which similarly look out onto a garden courtyard. The outside inhabits the inside and vice versa; the nest-boxes inside the gallery mirror those in the trees, just as the boxes are the 'doubles' of the birds illustrated on the stamp 'specimens' from which they derive.

Opened out, the nest-box form suggests the figure of a bird in flight, and this publication contains such schematics for all thirty-four birds in *Specimen Colony*, providing a beautiful exposition of the process, as well as being works of art in their own right. The project has opened up many interrelated ideas, a sample of which Alec was keen to represent in the book. Bird names have therefore become the central stem for mesostic poems, and further bird poems are seen in circular postmarks. Bird names also appear in song and as the solutions to cryptic crossword clues, painted onto nest-boxes and installed in various locations in the UK and Europe, represented here by photographs. *Blackbirds* is a sequence of ink drawings on stamps, in which flying birds become silhouettes. *Birdhouse*, a photographic record of an installation developed in collaboration with Alexander and Susan Maris, considers the presence of birds in the home as quiet colonisers. This book functions therefore as a central co-ordinate for all these projects and ideas, and provides a key for the nest-box sculpture and website, with its ongoing invitation to create your own box and colour scheme.

I would like to congratulate Alec on creating such an imaginative and delightful intervention into the Bluecoat spaces, a perfect welcoming as we re-inhabit the building. It is a response that chimes with our ambitions for the new Bluecoat to be a focus for creative participation, a microcosm of the hybrid city, a place of chance encounters, finding the unexpected within the familiar. I would also like to thank all those who have helped realise *Specimen Colony*: Alec's collaborators Jo Salter and Andrew Morley, Alexander and Susan Maris, Iain Pate, Eleanor Cherry and Alex Hodby; Bluecoat staff, especially Exhibitions Curator Sara-Jayne Parsons, as well as Chief Executive Alastair Upton, Head of Participation Bec Jones, Project Director Julie Ehlen and Head of Operations Sue Baker; Tree Health Consulting, Liverpool and Austin-Smith: Lord; our co-publishers Liverpool University Press, in particular Robin Bloxsidge; Arts Council England, the Esmée Fairbairn Foundation and Liverpool Culture Company for their funding towards the commission.

Bryan Biggs, Artistic Director, the Bluecoat

[1] *Extract (with original spelling) from poster poem by Don Van Vliet, aka US cult rock musician Captain Beefheart, for his first exhibition of paintings at Bluecoat Gallery in 1972.*

CONTENTS

SPECIMEN COLONY (THE SIX COLONIES)
Nest-boxes, colour specified from postage stamp specimens
Alec Finlay, artist concept
Jo Salter, nest-box schema designs
Andrew Morley, painted nest-boxes
Alexander Maris, photographs

THE RECOGNISABLE BIRD (POEM-NARRATIVE)
Alec Finlay
Jo Salter

MY BIRD BOOK (INTERVIEW)
Alec Finlay
Iain Pate

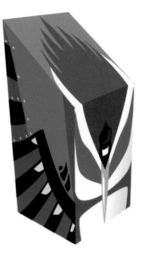

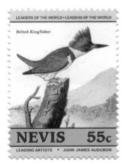

NB01 Belted Kingfisher
Megaceryle alcyon, Nevis 55c

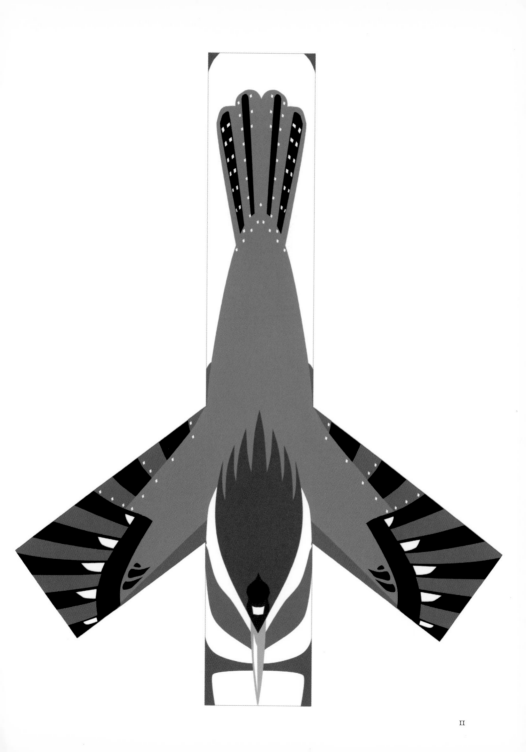

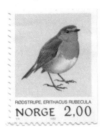

NB02 Robin
Erithacus rubecula, Norway 2.00

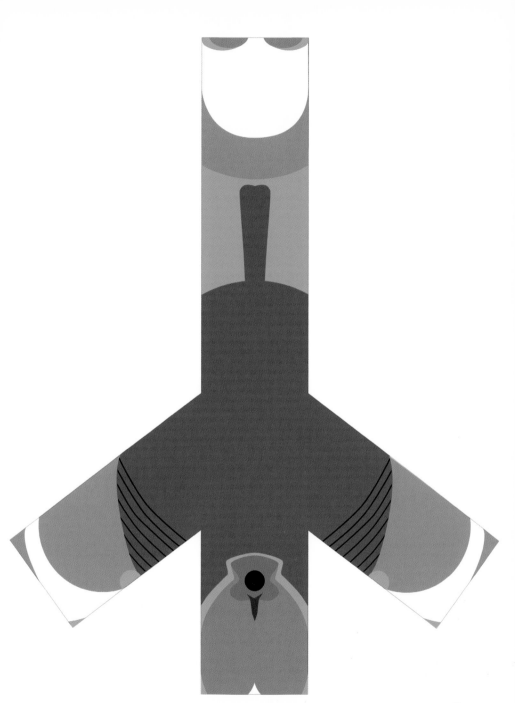

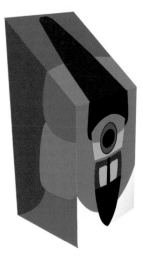

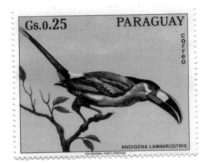

NB03 Plate-Billed Mountain-Toucan
Andigena laminirostris, Paraguay Gs 0.25

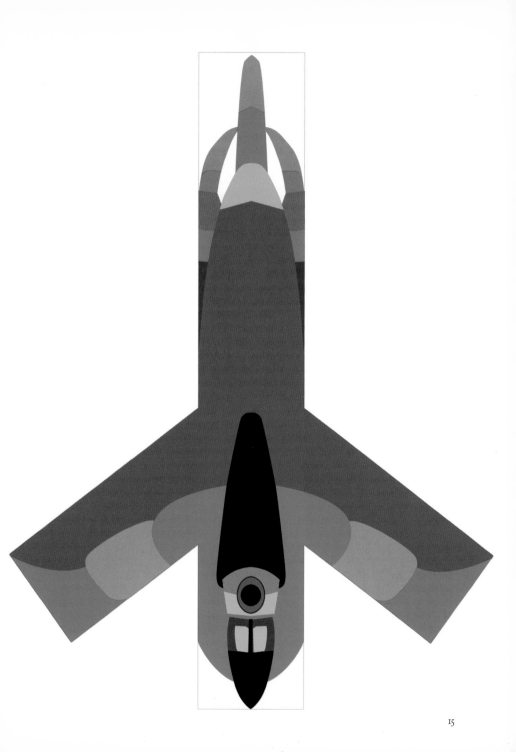

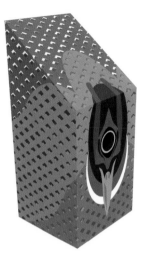

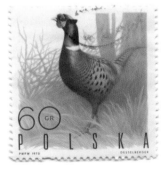

NB04 Pheasant
Phasianus colchicus, Poland 60gr

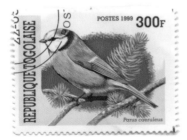

NB05 Blue Tit
Parus caeruleus, Republique Togolaise 300F

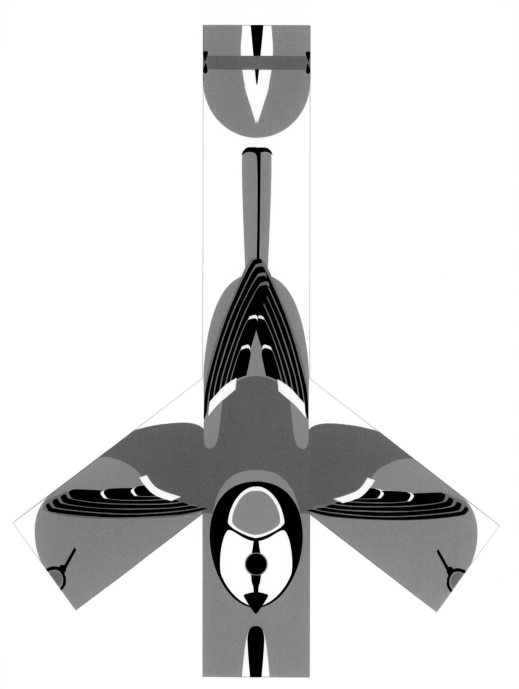

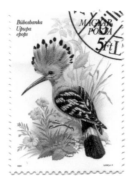

NB06 Hoopoe
Upapa epops, Hungary 5Ft

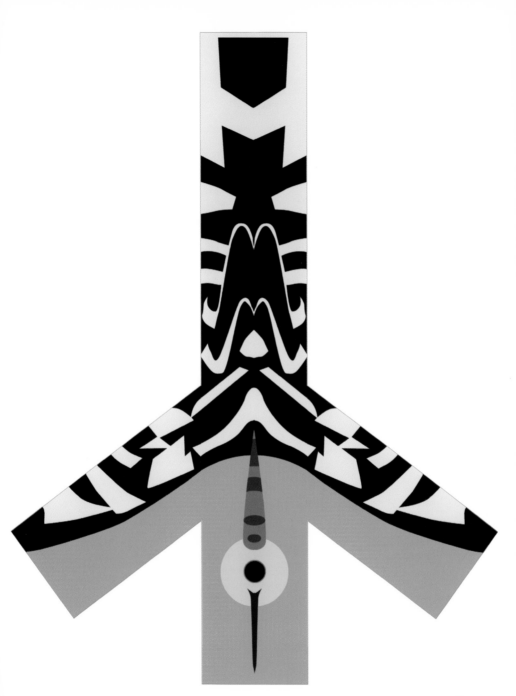

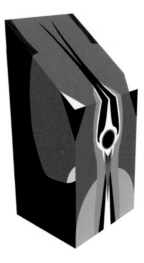

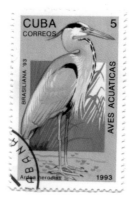

NB07 Grey Heron
Arcea cinera, Cuba 5

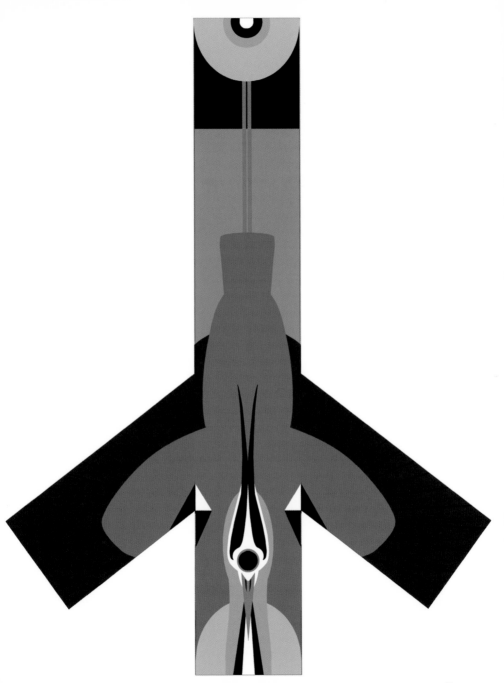

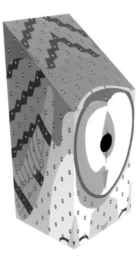

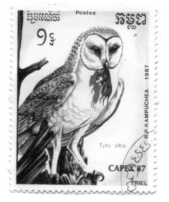

NB08 Barn Owl
Tyto alba, Kampuchea 9

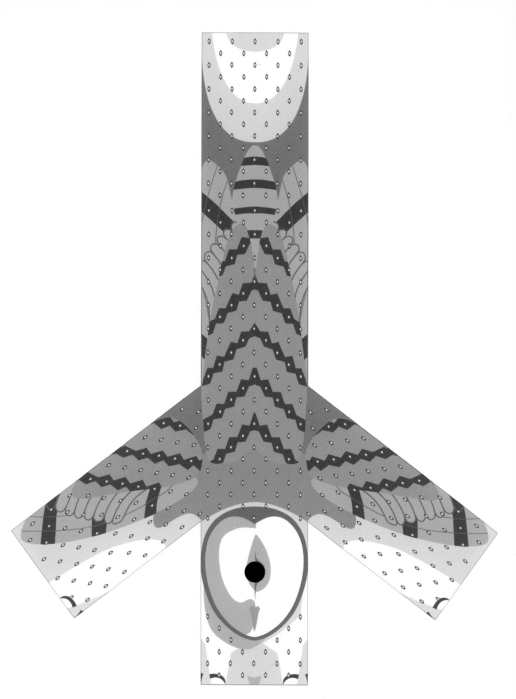

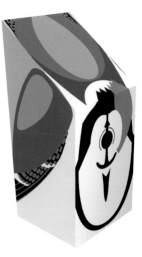

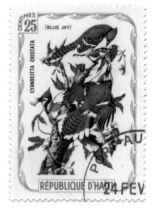

NB09 Blue Jay
Cyanocitta cristata, Republique D'Haiti 25c

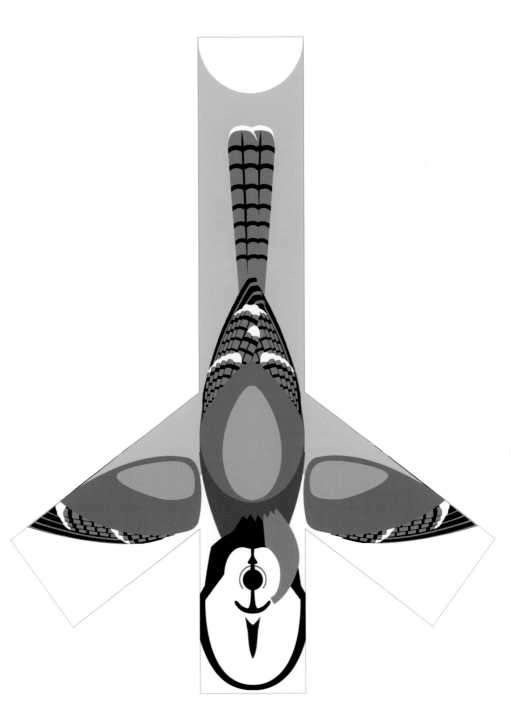

NB10 Lesser Flamingo
Phoeniconaias minor, Kenya 80/-

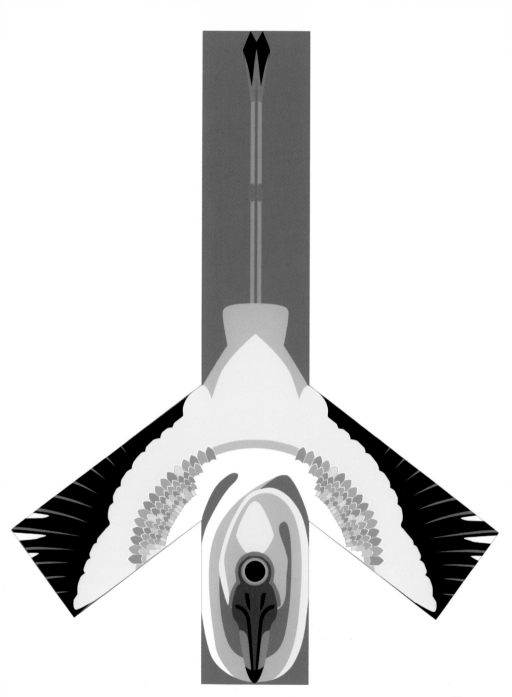

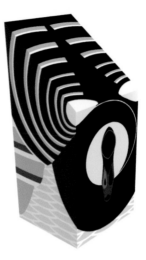

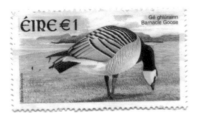

NB11 Barnacle Goose
Bracula leucopsis, Eire €1

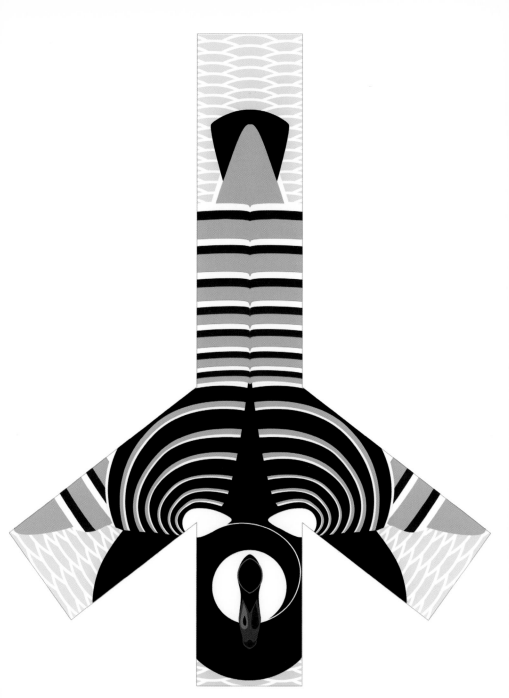

31

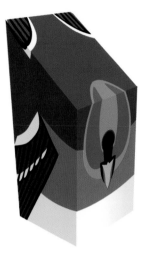

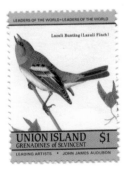

NB12 Lazuli Bunting (Lazuli Finch)
Passerina amoena, Union Island $1

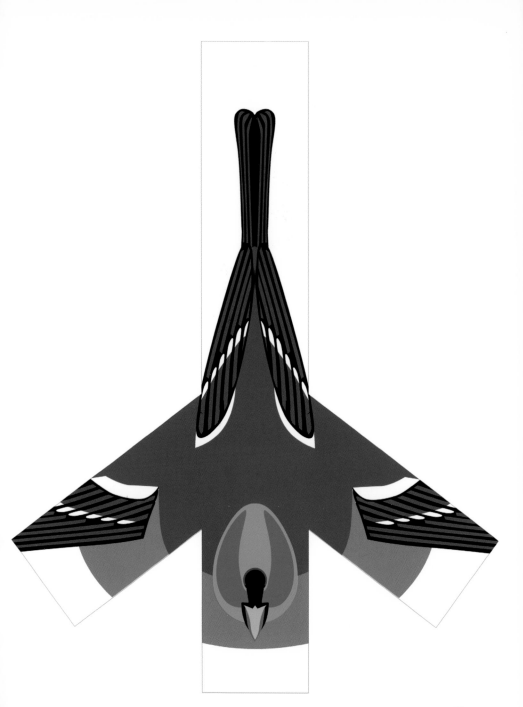

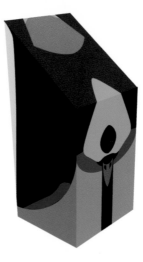

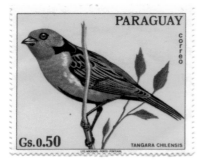

NB13 Paradise Tanager
Tangara chilensis, Paraguay Gs 0.50

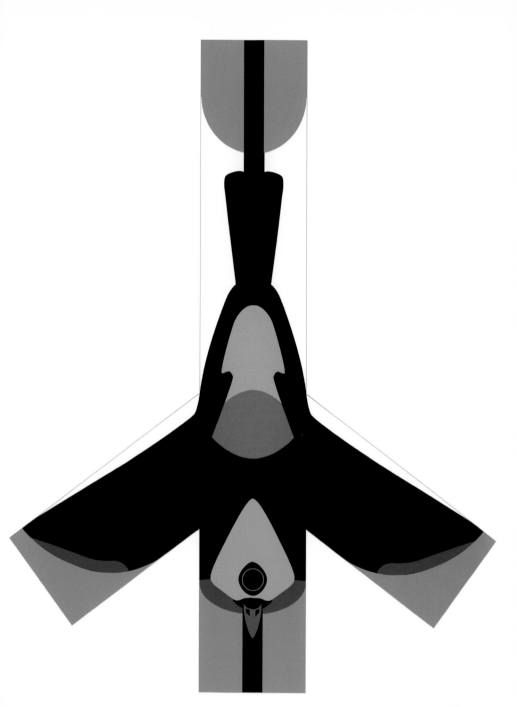

NB14 Cardinal
Cardinalis cardinalis, USA 20c

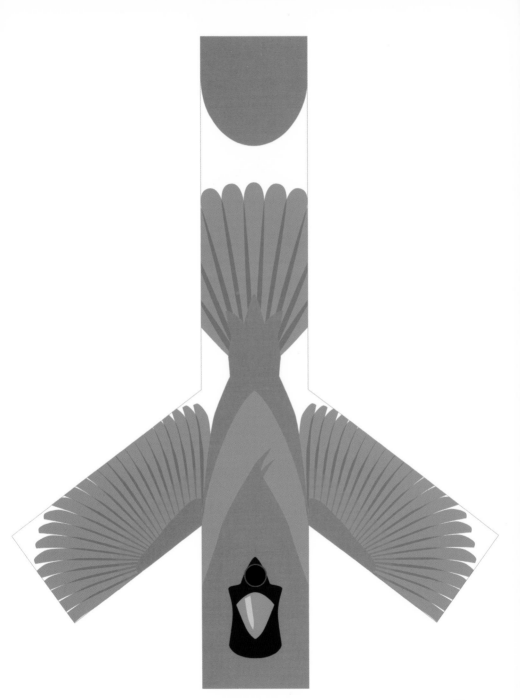

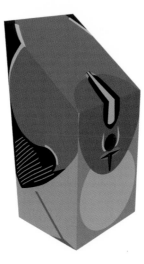

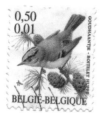

NB15 Goldcrest
Regulus regulus, Belgium 0.50

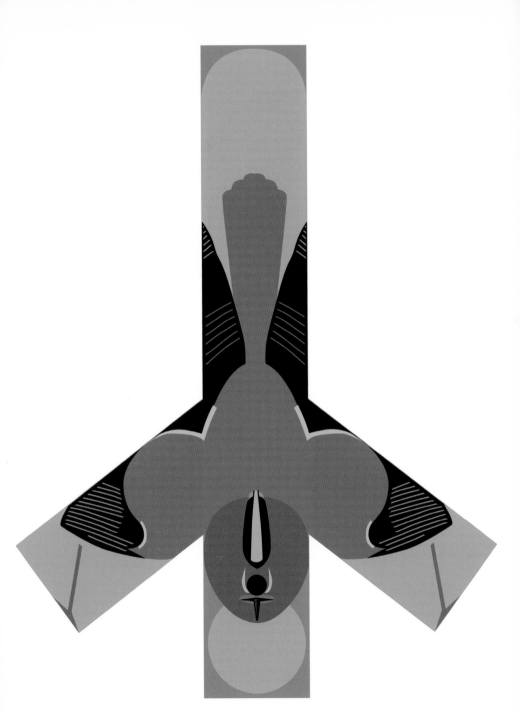

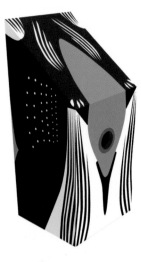

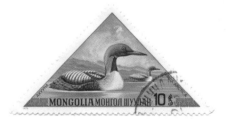

NB16 Black Throated Diver
Gavia arctica, Mongolia 10

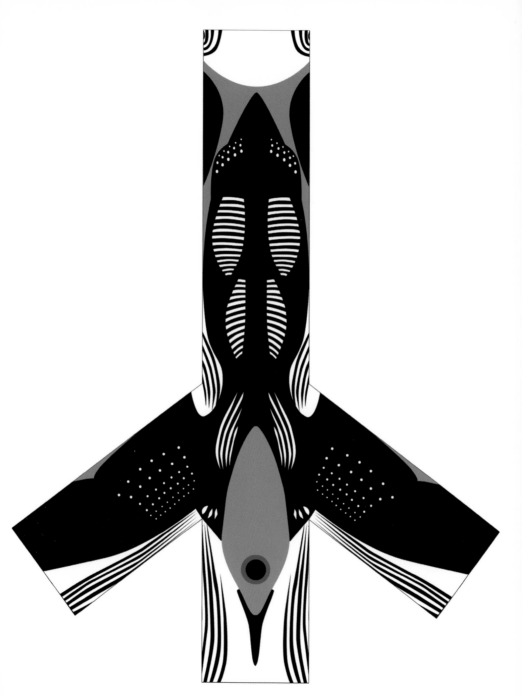

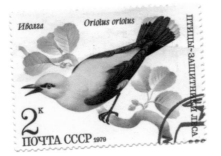

NB17 Golden Oriole
Oriolus oriolus, CCCP 2K 1979

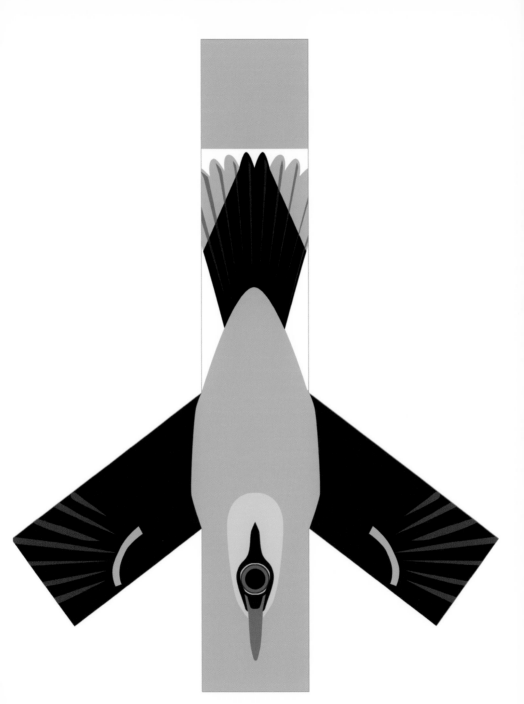

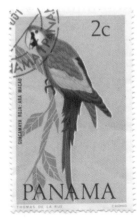

NB18 Scarlet Macaw
Ara macao, Panama 2c

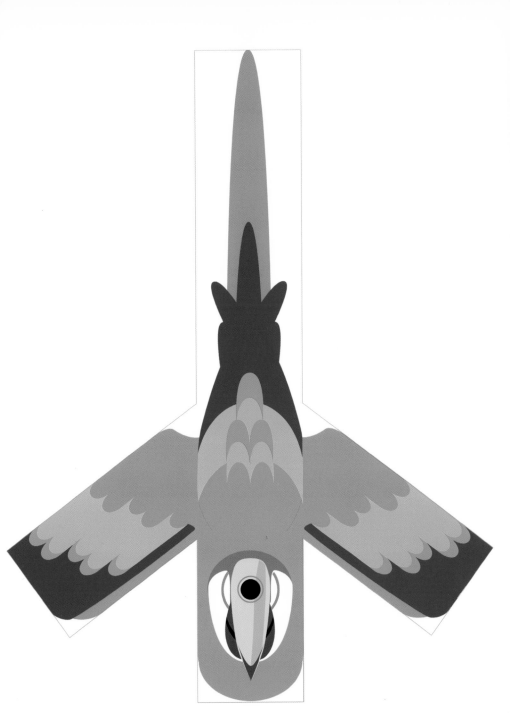

45

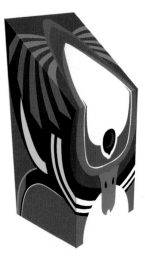

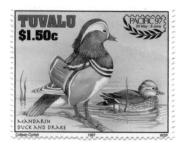

NB19 Mandarin Duck
Aix galericulata, Tuvalu $1.50c 1997

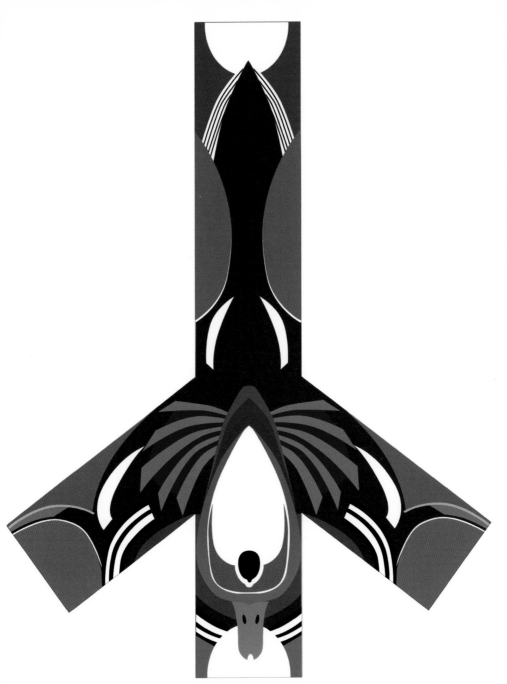

47

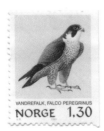

NB20 Peregrine Falcon
Falco peregrinus, Norway 1.30

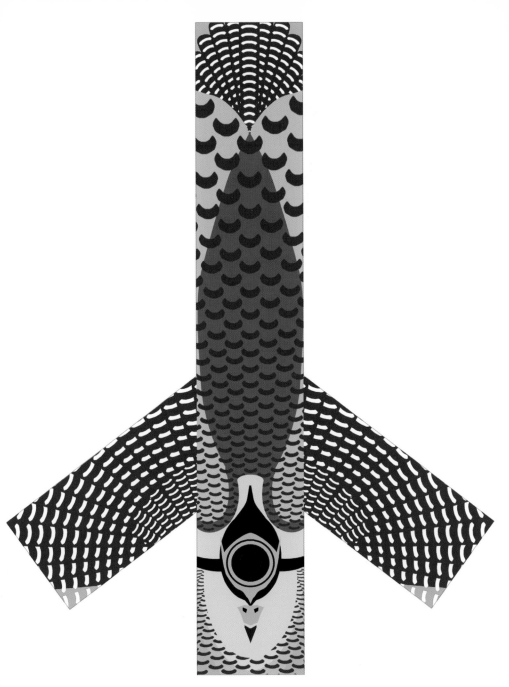

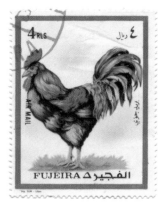

NB21 Cockerel
Gallus gallus, Fujeira 4rls

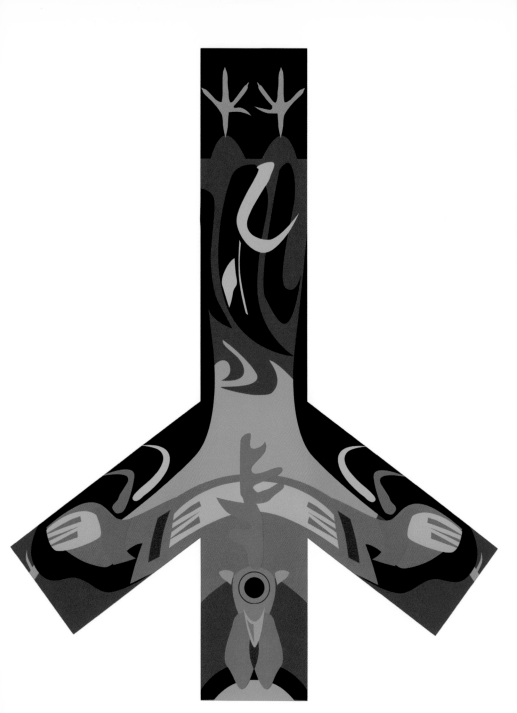

NB22 Mallard Duck
Anas Platyrhnchos, Republique D'Haiti 1

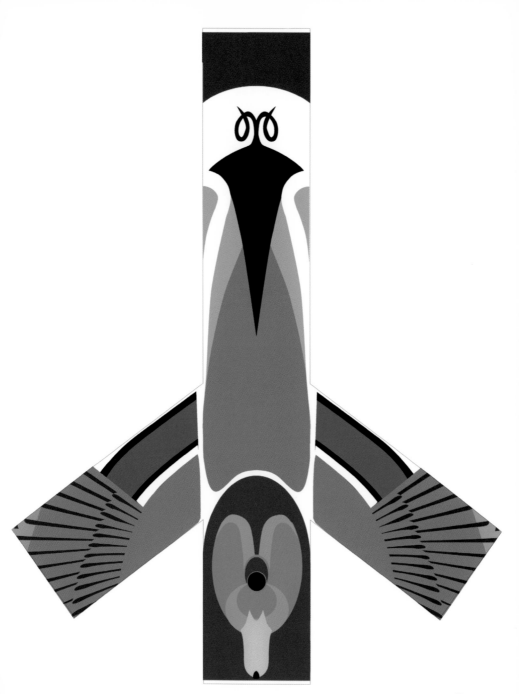

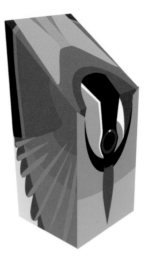

NB23 European Bee-Eater
Merops apiaster, Hungary 5Ft

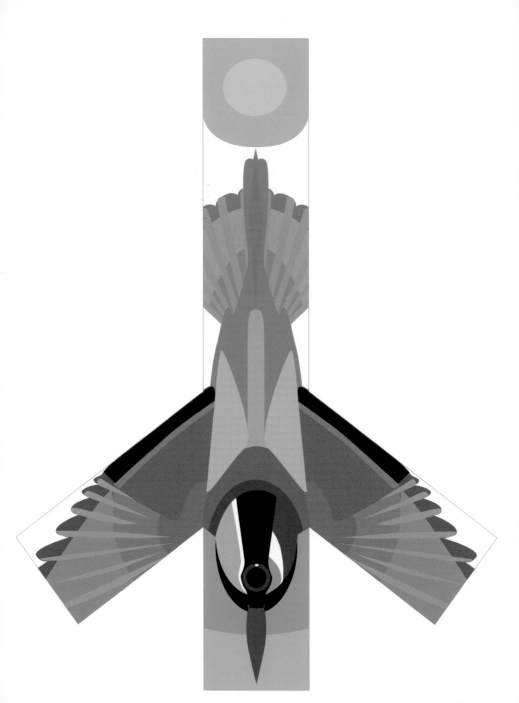

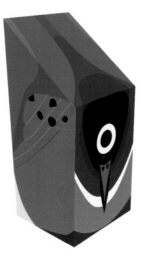

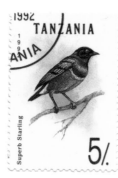

NB24 Superb Starling
Lamprotornis superbus, Tanzania 5/.

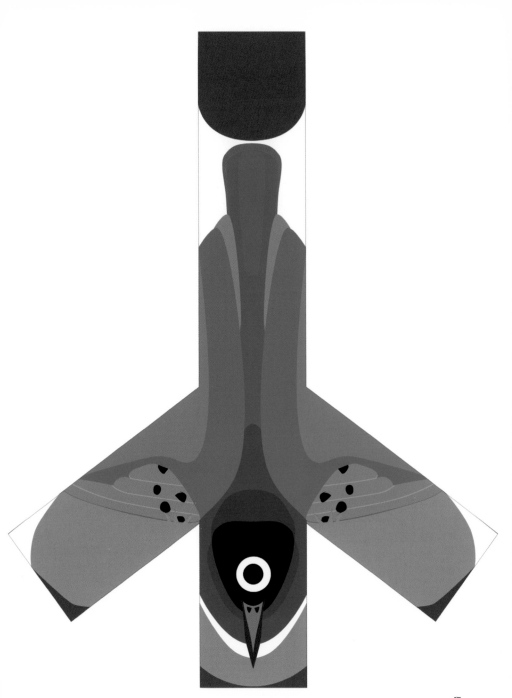

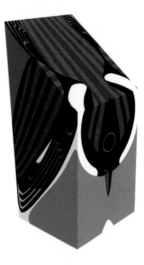

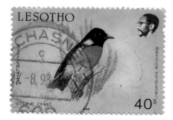

NB25 Stone Chat
Saxicola torquata, Lesostho 40s

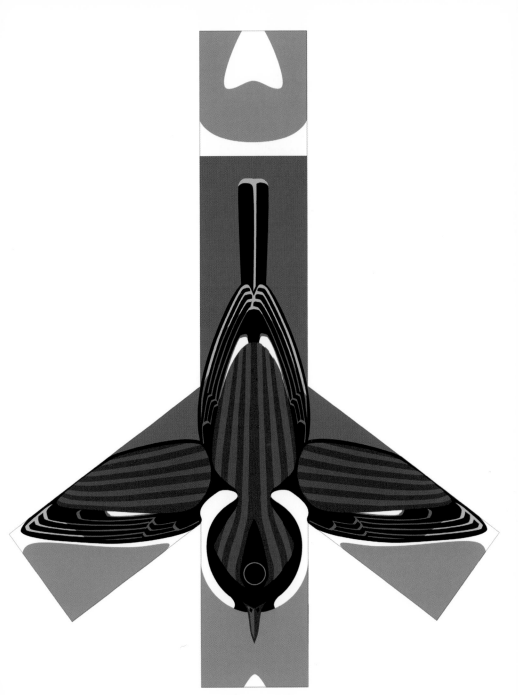

59

NB26 Indian Pitta
Pitta brachyura, India 25

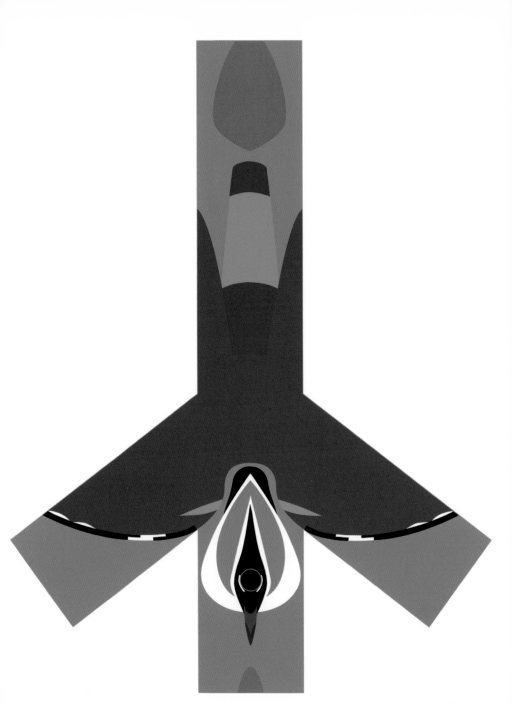

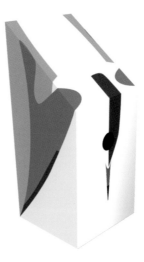

NB27 Roseate Tern
Sterna Dougalii, Republique D'Haiti 50c

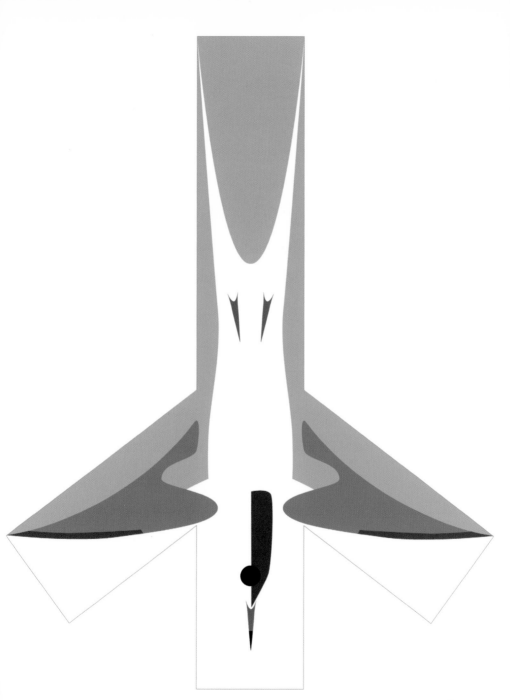

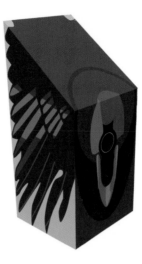

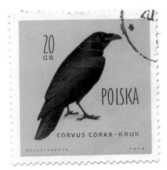

NB28 Crow
Corvus corax, Poland 20GR

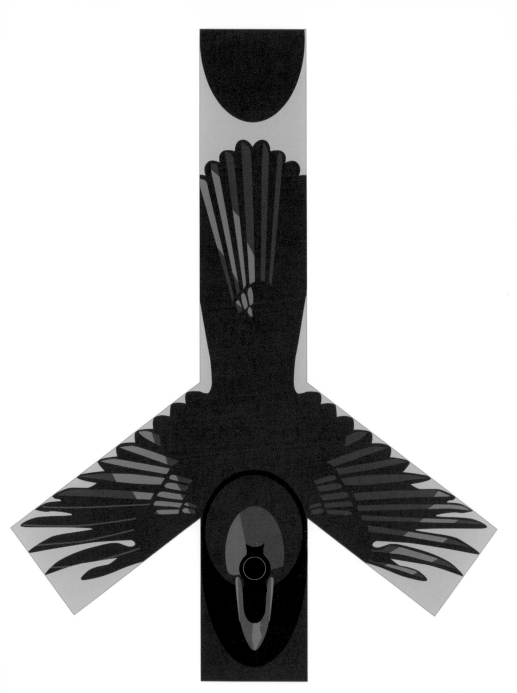

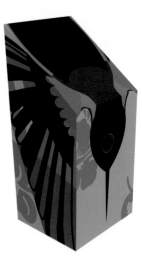

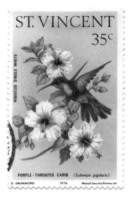

NB29 Purple-Throated Carib
Eulampis jugularis, St Vincent 35c

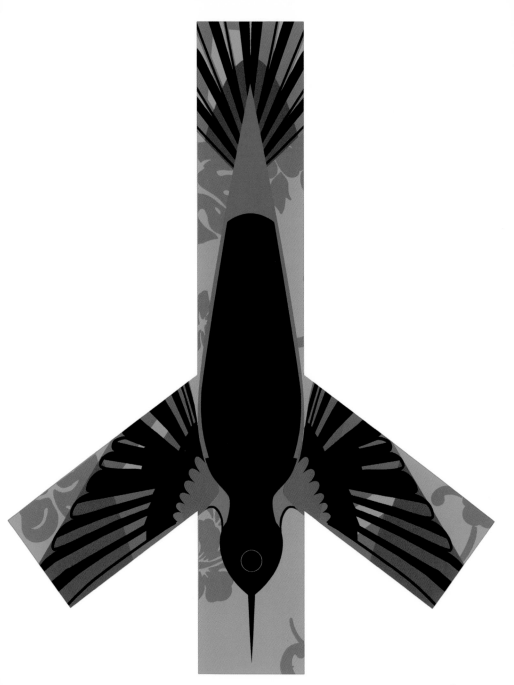

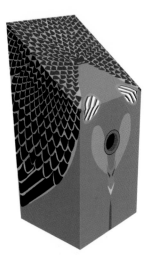

NB30 Red Turtle Dove
Streptopelia tranquebarica, Vietnam 20

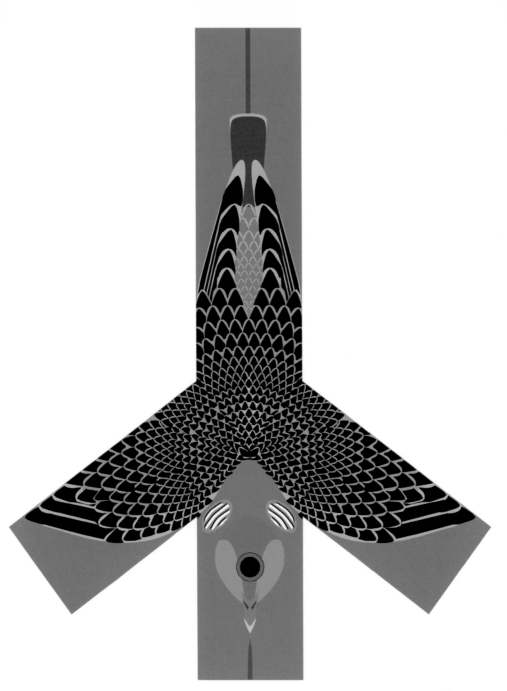

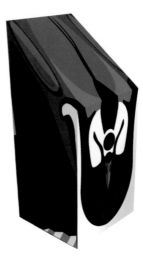

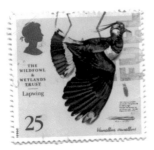

NB31 Lapwing
Vanelius vanelius, Great Britain 25

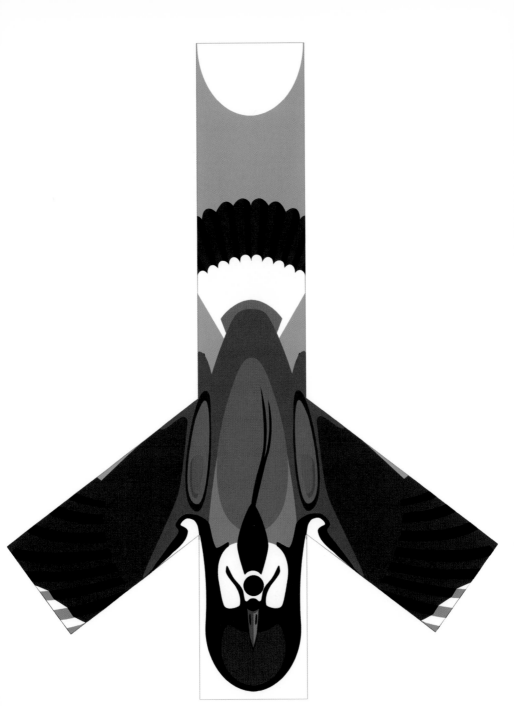

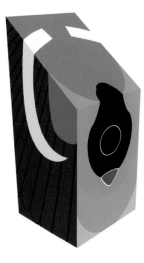

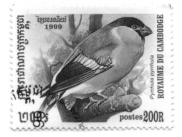

NB32 Bullfinch
Pyrrhula pyrrhula, Cambodia 200R

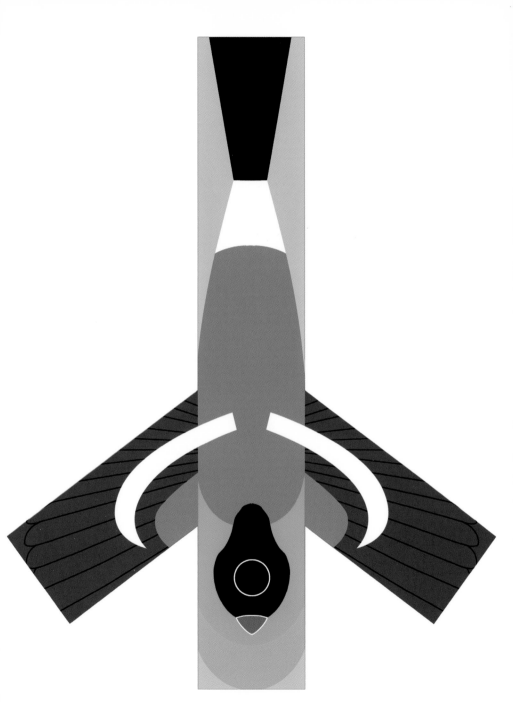

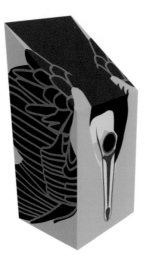

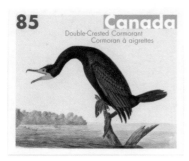

NB33 Double-Crested Cormorant
Phalacrocorax auritus, Canada 85

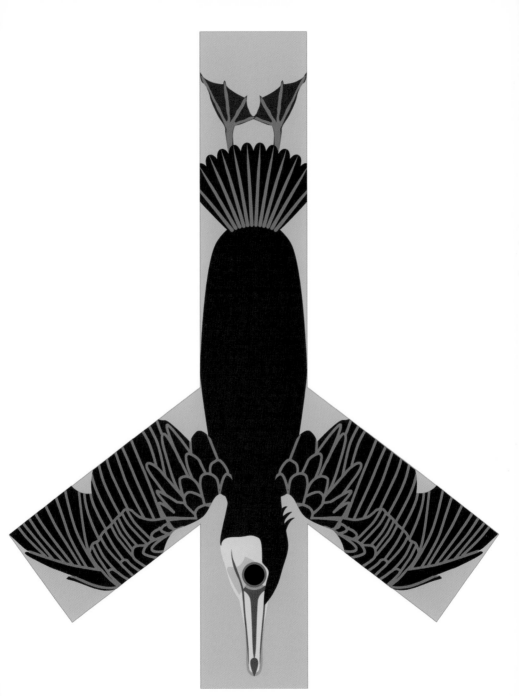

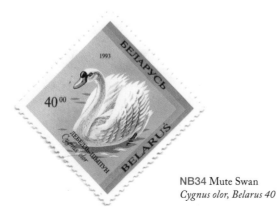

NB34 Mute Swan
Cygnus olor, Belarus 40

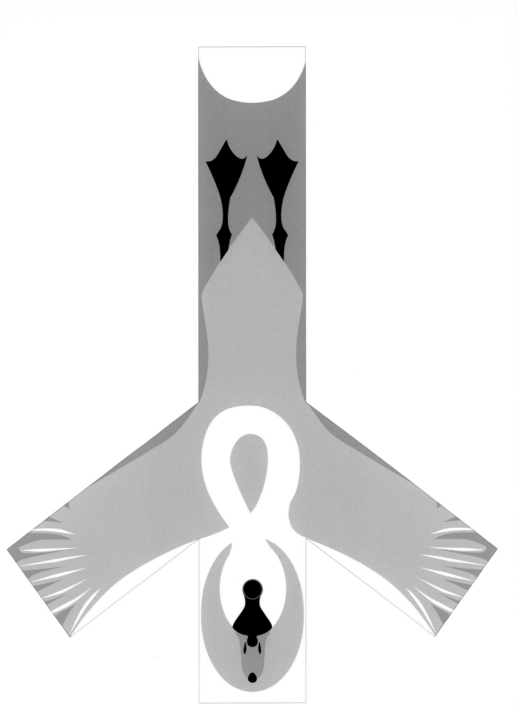

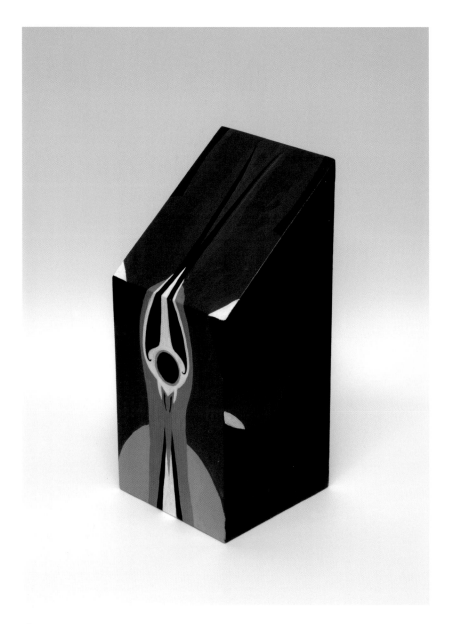

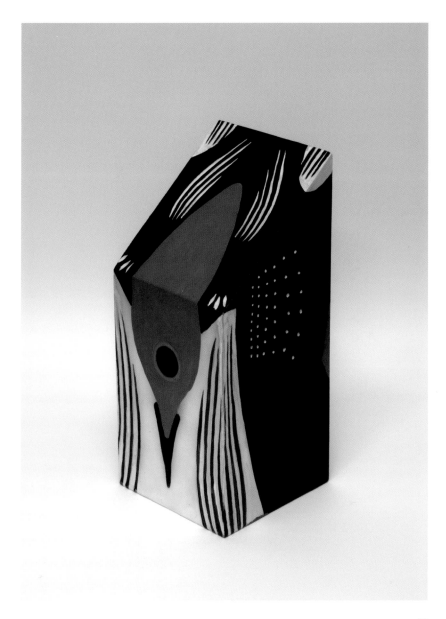

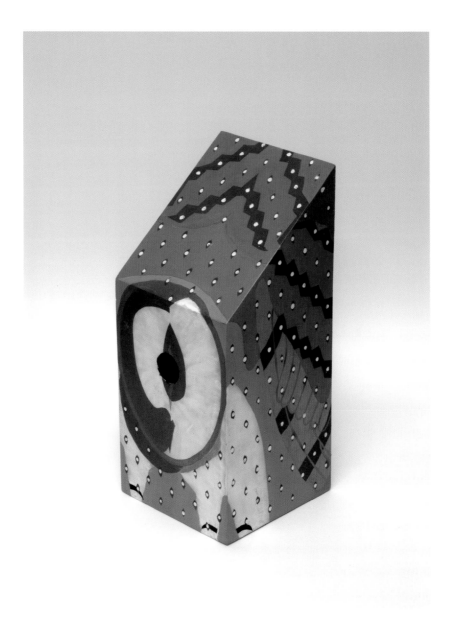

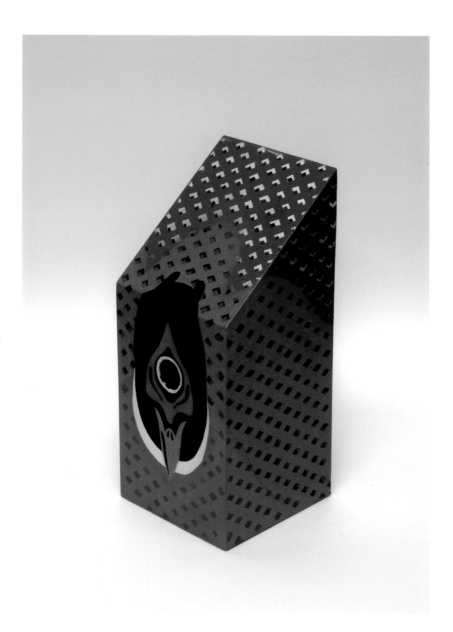

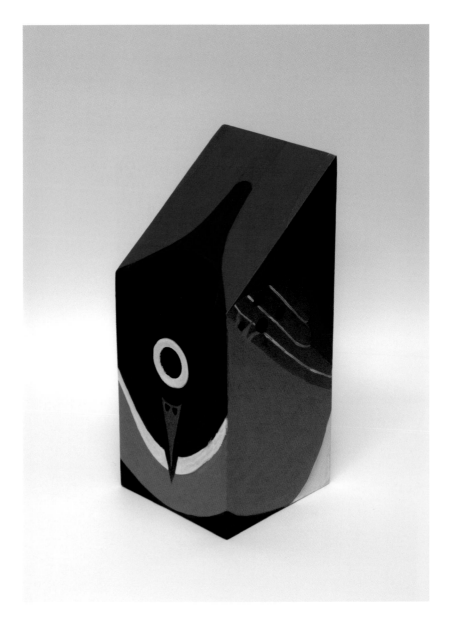

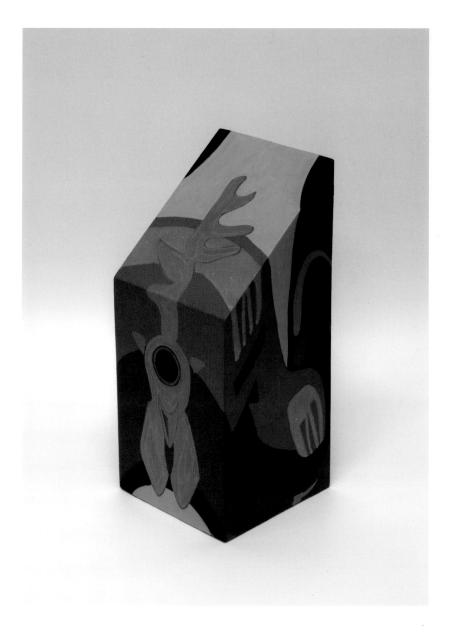

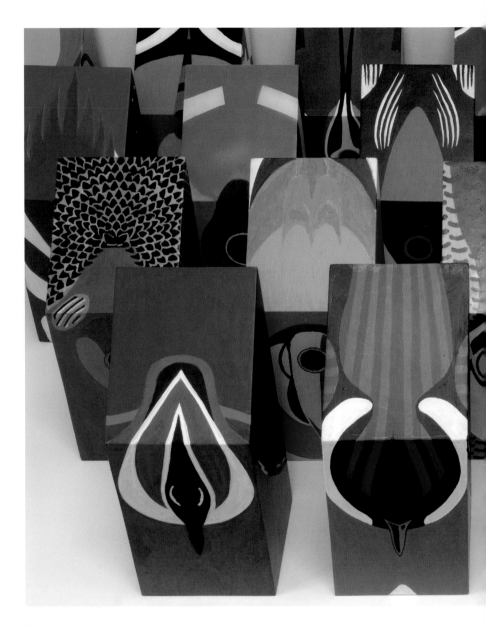

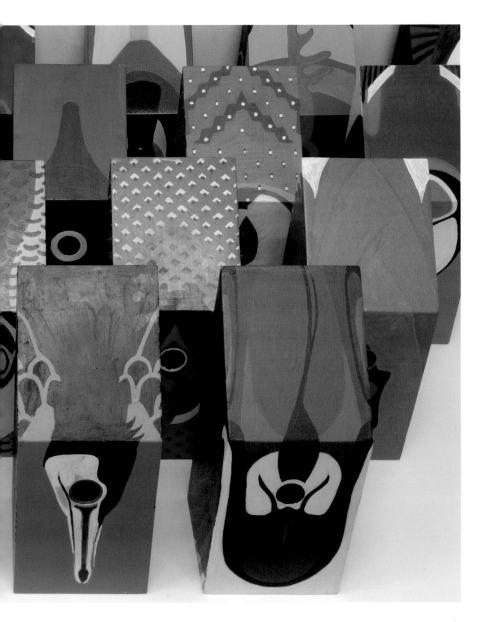

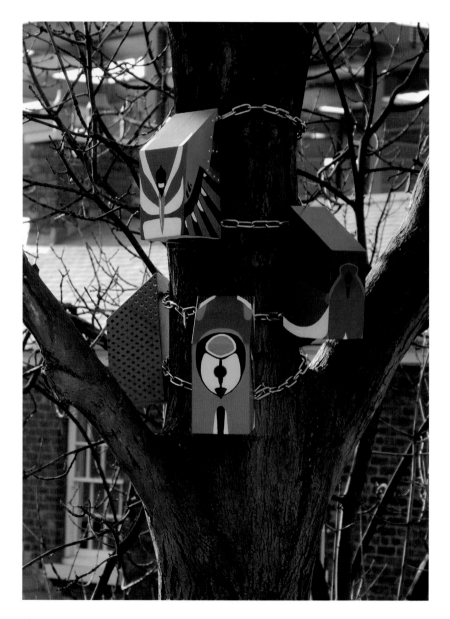

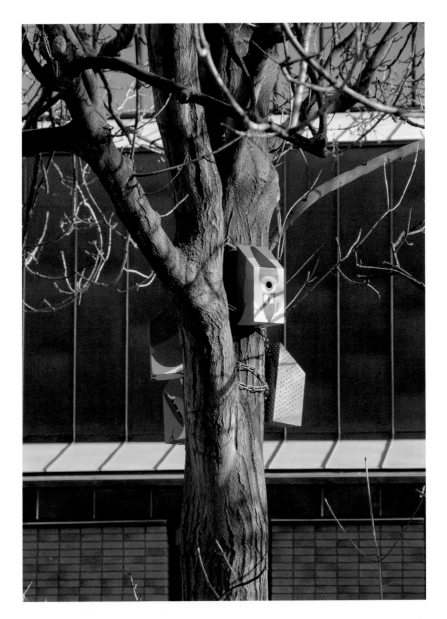

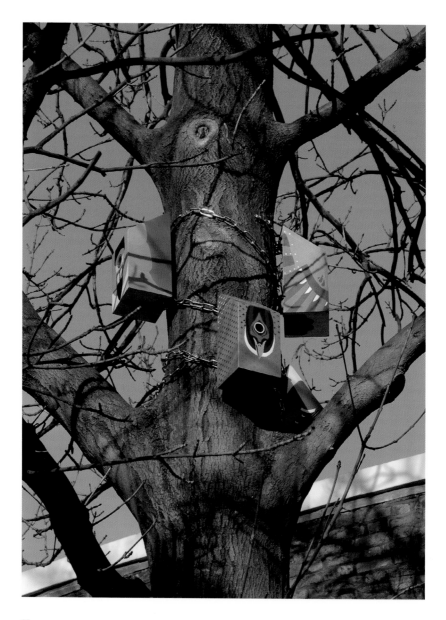

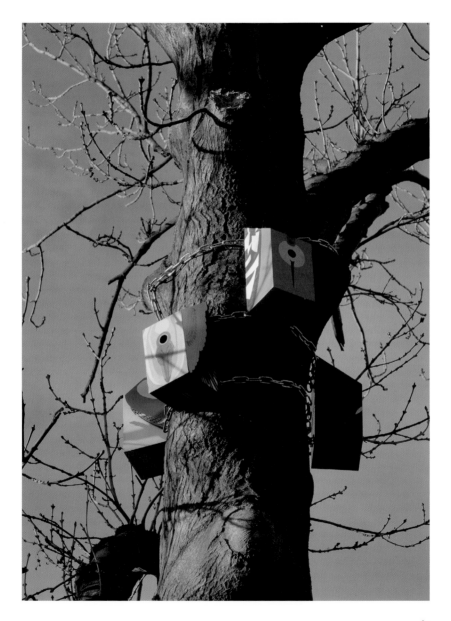

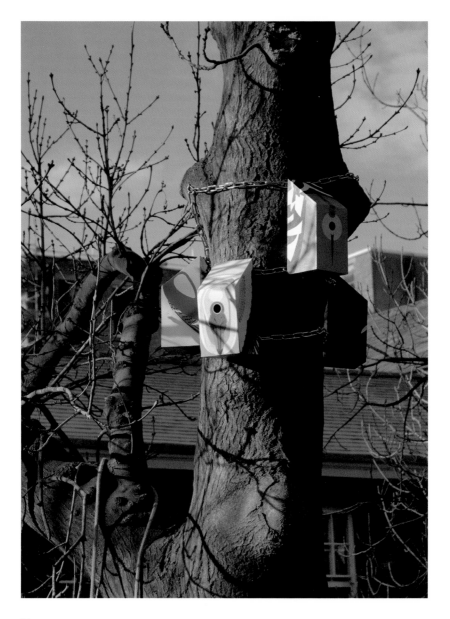

SPECIMEN COLONY (LOCATIONS)

'When I put the barn owl nest-box out to dry in the sun the seagulls went silent.'
—*Andrew Morley*

*There are six complete colonies of nest-boxes, each representing five bird species,
sited in the trees on School Lane in front of the Bluecoat and in its garden.
The Cormorant nest-box is located indoors at the Bluecoat. The Lapwing, Bullfinch
and Swan nest-boxes are located at other sites in the city of Liverpool.*

THE RECOGNISABLE BIRD

I. The Recognisable Bird

The nest-boxes are composed
from the bird's component parts.
Each design diverges

from the recognisable bird,
enjoying the ambiguity of aircraft
markings or railway signals;

the colours specified from postage stamps,
each specimen interpreted flexibly
and harmonised with a bird in the wild.

A bird is not curves drawn as line
but shapes composed as pattern,
elements transposed onto a cruciform

plan, a spread-eagle schema
where the rake of each side reads
as the sweep of wings.

Fold into a box, wings tucked in
like a sentry; the hole not a bullet
in the breast, but a dark hollow eye;

the beak a strong vertical;
legs, an occasional feature,
need not always be included.

II. Multicolourful

The birds were selected for bold designs:
recognisability – Barnacle Goose,
Hoopoe, the tasteless Tanager –

uniqueness – Toucan, Mandarin –
not too many Finches and Tits,
small birds with similar shapes;

for their associations: the Cormorant
a friend for the golden Liver Bird
with his sprig of laver;

and some for their beautiful names –
Indian Pitta, Superb Starling –
with a handful of Audubons in homage;

and specimens chosen for their stamps,
their countries, relics of Empire,
new states, patchwork maps –

emblems of migration and diaspora,
a hybrid community nestling
in the arching branches of plane & ash.

III. Colony Birds

The first bird drawn is a Peregrine Falcon, (NB20)
composed as wallpaper
and distinguishing features:

yellow yachting wellies
like indicator lamps up front,
roof like a Swaledale farmer's cap.

The Kingfisher is Belted, after Audubon. (NB01)
Where he is blue, his girlfriend is green.
Robin (cock), more subtle than a red-top;. (NB02)

Bullfinch, more red breast – (NB32)
 with a sabre flash across his wing.
 On a grey morning the Heron (NB07)

bends down to touch his toes.
 The Hoopoe represents a departure. (NB06)
 The side of his box is the wing folded.

A highlight is his dynamic cubism,
 shades of battleship markings.
 He would make a fine kimono.

The Lazuli Bunting is true to the stamp (NB12)
 and Audubon's muted colours.
 These will appeal to some

though not the bird in the wild.
 The Barnacle Goose is non-symmetrical: (NB11)
 eye straight & sideways, spiral neck

curves by the grace of 'vectors' *(Illustrator)*;
 pleated downy underwear; vigilant.
 I fed one that got left behind on Uist,

which the Policeman's son then shot.
 Crow, Metallica Goth, his beak (NB28)
 a ring pull or door knocker;

a finger-like silhouette in winged flight.
 The exotic background of the St Vincent
 Carib postage stamp led me astray, (NB29)

adding a hibiscus floral pattern.
 The ornate Mandarin is a sword curve. (NB19)
 I have been faithful to the Cardinal. (NB14)

He is flying three spread fans
 narrowly connected to a small body
 and seems to refer to the Ku Klux,

or their predecessors, the Semana Santa
 brotherhoods of ancient Spain,
 as well as a certain brash Americanism.

He makes no attempt to hide
 except perhaps in a fire station.
 The male Pheasant is confounding, (NB04)

an infinite optical illusion
 of shiny tessellation and *trompe l'oeil.*
 This woodsman is from Poland.

The Barn Owl, also patterned, (NB08)
 is more autumnal altogether,
 with wonderful peepers in his feathers.

Our Dove is Rufus, (NB30)
 a specimen from Vietnam.
 His neat and colourful neck

markings, akin to an air vent or gill,
 serve no obvious function.
 The little Goldcrest has a flash (NB15)

yellow mohawk and tacked on
 drawing pin beak.
 The Blue Tit is wearing (NB05)

the neatest waistcoat and tails.
 The Indian Pitta has the head (NB26)
 of a Kathakali dancer from Kerala.

Art imitates Nature imitates Art.
 Do the birds reflect or influence
 their vernacular culture?

The Tern is Roseate, a Cornish (NB27)
 seaside camouflaged destroyer
 honed to cut a blade through water.

The beak and feet are a repeat.
 The Bluejay, another Haitian stamp (NB09)
 fake, felt contorted

until I resolved the conundrum
 of one eye and portrayed him
 head sideways / head straight.

Look, a Liver! The Great Cormorant. (NB33)
 Where Crow is oily haggard darkness,
 Cormorant dries heraldic wings

in a refined and careful fashion.
 His arrowed shape is literal.
 The British Lapwing has three names. (NB31)

This dandy Gordon Highlander has
 a feather cap and moorland battle dress.
 His flight is awkward, nervous;

ever alert, he carries weight
 on the end of his wings,
 The Mallard is a bright soup (NB22)

of colour and shape, a sumptuous clown
 with piggy-tail locks.
 The Superb Starling is a shiny cylinder (NB24)

of polished copper and verdigris.
 The button eye is ivory white,
 which the hole of the nest-box

reverses into a shocking blank stare.
 The Swan is Mute, from Belarus.
 She's not blue; she has the stamp's shadow. (NB34)

Despite being cubed, she retains grace.
 Her watching head rests in an egg shape.
 She waits for bread. Graceful,

also comic, the Flamingo is Lesser, (NB10)
 from Kenya, with an ornamental bill,
 lanky skateboy knees;

pure pink with darker ruffles,
 an air of Quentin Crisp.
 From Panama, the Scarlet Macaw, (NB18)

contra common sense,
 has an eye that appears to rest
 in the middle of his beak.

I saw a Black-Throated Diver up close (NB16)
 on Dun Caan, Raasay, and they nest
 near my house at Minish

in the blackest of Hebridean lochans.
 I adore this bird's sleek design:
 the grey bathing cap housing

a bloodshot eye and tapered
 hypnotic trackshoe flashes.
 The Tanager is in Paradise, (NB13)

Paraguay; his *Lucha Libre* wrestling mask
 breaks all fashion rules.
 The Toucan is a high priest of the Aztec. (NB03)

The Stone Chat, from Lesotho, (NB25)
 blends African bush
 with English blazer & boater.

The Oriole is bold and stylish: (NB17)
 yellow fuselage & black wings,
 which read independently –

by day golden sky; by night
 yellow bullet, an avian Zorro!
 The Bee-Eater is European, (NB23)

a subtle gentle harlequin
 whose multicolour is multi-
 plied by the silken shimmer

of his wing. Hovering he holds
 insects, stings at bay in an X-long beak.
 The Cockerel is a riot. (NB21)

Added to his homely Kellogg's appeal
 is the Navajo Indian influence
 of the red cactus that perches

on top of his head.
 His erect shape works well as a box,
 being blue, being sky above farmyard.

Note

John James Audubon (1785–1851), American ornithologist, naturalist, painter and hunter, author of Birds of America *(1827-1838) and* Ornithological Biographies *(1827–1839, with William MacGillivray).*

If not otherwise indicated the birds illustrated for Specimen Colony *are male, following the general rule in nature that the male is the more brightly coloured. The male and female Hoopoe both have a coxcomb. Kathakali dance is only performed by men. The Scarlet Macaw must be examined to establish gender. Audubon says of the Great Northern Diver: 'The female is smaller than the male, but is similarly coloured'.*

POEM-NARRATIVE
Alec Finlay & Jo Salter

MY BIRD BOOK

'It's like when a bird flies in the room…'
— *Marcus Coates*

Iain Pate: Which came first for you, the birds or the boxes?

Alec Finlay: The garden. The Bluecoat were improving their existing garden at the same time as transforming the architecture of the gallery. The thought went in steady steps: from the garden, to the Liver Bird, to the character of a contemporary European 'gateway' city – especially, in historical terms, a port like Liverpool – imagined as a bustling colourful colony, a confusion of exotic and native birds.

I love the nest-box form as a sculpture and an object with a function, a home. They give a point of interest, but unlike the plinths in Trafalgar Square or any number of statues, they don't impose themselves at street level. They are also safer up there, out of reach.

The catalyst for the whole project was when I made a sketch plan of a nest-box and realised that opened out the schema has the form of a flying bird.

IP: You've used the nest-box in previous works.

AF: Yes, as a fond found form; as a carrier for a text in an ongoing project, *Field-Guide* – cryptic crossword clues composed on the names of birds. These exist at various international locations (Yorkshire Sculpture Park, Dysart, Milton Keynes and Bad Homburg). In its reach, in the way that it could occur anywhere there are trees and birds, *Field-Guide* relates to other projects, such as *Wind Blown Cloud* (an archive of photographs of the sky) and *worldwiderubberstampletterboxcirclepoem* (a mapping project placing 100 letterboxes at locations around the globe). The letterboxes that I use are small wooden boxes with hinged lids, each containing a rubber stamp and ink pad. Being similar in form to nest-boxes they may originally have suggested them.

A few years before (2001–02), I made a public artwork referring to the Sufi classic *The Parliament of the Birds*, for the hidden gardens, (tramway, Glasgow), for which I had transcriptions of the songs of seven symbolic birds painted onto different nest-boxes.[1]

Somewhere in the background of these works is *glossolalia*, a love of birdsong connected to pure sound and sound poetry – Ken Cockburn and I included examples of birdsong poems in the pocketbook

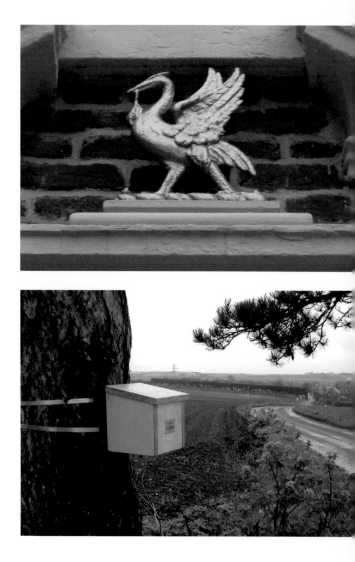

anthology of Concrete and Sound poetry, *The Order of Things*. I always loved the musicologist John Purser's statement that the first music in Scotland was the song of the snow bunting.

The nest-boxes in *Specimen Colony* reflect a shift away from text towards the possibilities of colour, and the birds – and the postage stamps they are taken from – are another found element. But looking back on my work what the box has in common is that it is a form, a frame, and in that sense it's no different to a haiku, renga, mesostic, proposal, circle poem, or any of the other forms I've worked with.

IP: What was your selection process with the stamps? Are you consciously considering the relationship between the country in which the postage stamp is produced, or the country which the bird is native to?

AF: The question of selection has a number of aspects. In a Darwinian sense, I was concerned with simple forms/complex operations – standard schema form/multiple colourful derivations. The project was for a city whose chosen symbol is a bird, a heraldic version of the cormorant. My intention was to portray this vibrant heterogeneous multicultural city. You could also say that the colours reflect the witty and cocky characters you find in Liverpool. The specimen colonies in the trees around Bluecoat are a kind of caricature.

Postage stamps are by their very nature political works of art, currency, symbols of modernity and travel. Back in 1996, before devolution and when I still lived in Edinburgh I curated an exhibition of new postage stamp designs for an 'imagined Scottish Republic', for which we printed over 100,000 stamps (*Imagined Lands*, City Art Centre). My argument was that if you had the stamps you were halfway there. After the devolved Parliament was agreed but before it was built, I edited *Without Day*, an anthology of proposals for a new Parliament, none of which was to be realised. I suppose *Specimen Colony* is a refinement of these utopian projects.

Although birds do have a strong sense of territory, they are not statist! They elude our political borders, as clouds do. Equally they are affected by our ecology, as clouds are. I decided against choosing stamps from countries that would replicate Liverpool's immigrant population – I wanted to go beyond fixed racial communities and create a sense of diversity that was wild. In a way, I wanted to let the birds be, not chain them to specific associations, though, of course, some are thrown up.

Birds suggest nomenclature, taxonomy, identity. There are thousands of bird postage stamps to observe, collect and arrange – they are one of the most commonly collected philatelical thematics. Looking at the stamps, they assert symbols, territorial claims, changes of political status, forgeries – for instance, the eagle, a symbol of imperium, like the Israeli eagle depicted flying over a desert landscape, asserts a claim; stamps of former colonies overprinted with declarations of independence; or the Audubon forgeries, perpetrated by the Duvalier regime in Haiti.[2] Audubon was himself the illegitimate son of a Haitian slave, and he is claimed by many a country's stamps.

Some of the stamps' narratives could be related back to a city like Liverpool. But I like to think of the birds as random acts of beauty, not coat pegs for ideas. They are also Romantic and suggest a child's utopian vision: 'Like Gulliver the child travels among the lands and peoples of his postage stamps.' (Walter Benjamin).

Instead of illustrating one particular argument – post-colonialism, ecology, etc. – I collected the greatest number of stamps I could and then randomly selected a range of attractive species, arranging these into colonies without any conscious rationale. The choices were personal and aesthetic; the only rules were that no country should appear more than twice and, where possible, each colony would have an Audubon. (The Haiti forgeries put a question mark over that rule).

IP: The colours in Jo Salter's nest-box illustrations are incredibly vivid; the bold painted lines and blocks presenting simplified versions of the birds' natural colours and patterning. In the selection process, how much of a concern was the suitability of each type of bird to the process of graphic reduction? Did you set yourself rules in order to try to ensure some semblance of continuity throughout the groupings?

AF: I did partly select according to their suitability for the final painted nest-box, and I had to limit myself to some extent, for instance, the flecked details of a peregrine and a pheasant, like an intricate carpet weaving, are heavy duty in terms of the labour and skill involved for Jo, and for Andrew Morley (who painted the boxes).

Another more important colour rule was to try and match the colours of the stamps, not the birds themselves – the stamps being our specimens, the only ones available to be observed closely.

This colour aspect is connected with a series of projects that I have been working on over the past three years concerned with colour specification, where natural elements define a range of colours. The first of these was my project for *East 05* (Norwich) *The Black Tulip*, which considered genetics, aesthetics and economics. There is no 'black' that lives in nature so, in terms of flora it becomes the rarest most valuable thing to breed (hence the financial speculation that caused tulipomania).

My original rule of referring to nature as a 'true' source for colours was deliberately undermined by the stamps. Colour in this project is hybrid: the difference between a found 'specimen' stamp and the sheen of a live bird. You could say that the stamps lack that lustre of the living feather. Also, the stamps produced in some countries are gaudy and cheap – mind you, the same thing could be said of some birds! Our bird/stamp specimens vary from country to country, with species variations introduced by the varying quality of lithography.

This book reproduces digitally drawn schema, which refer to a stamp, itself usually a reproduction of a painting (occasionally a photograph). The whole process is analogous to the complexity of identity – person, colour, pigment, race, gene, citizen, subject, fingerprint, eye. Rather than focus on the artwork as an end result, I was setting Jo a series of almost random challenges, to interpret, and then we passed the schema on to Andrew, to reinterpret as the actual nest-boxes.

Jo and I also established a historical relationship with Audubon,[3] who shot his subjects (by the hundreds, thousands), and who said their colours faded very fast. Audubon's plates were painted by others, guided by his originals, along with lengthy instructions and colour notes, first in a workshop of artisans in Edinburgh, and later in London. This 'production line' process is not so dissimilar to the one that led from myself (selecting specimens), to Jo (designing schema), and Andrew (painting boxes).

IP: So with the process of removal from an original, step by step, the illustrations become abstracted and complex. The proportions of the bird have also been distorted to fit a standard, the rectangular box schema, another layer of interpretation on the illustrator's behalf. You referred to your use of the nest-box as a 'carrier' in an earlier project, but in this instance the function of the box works more as a visual clue, helping the viewer resolve the nature of the illustration: once we know it's a nest-box, it's easier to identify the pattern painted on it as a particular bird.

AF: It is a thing, isn't it, the perfect flatness of the schema. The work doesn't start as sculpture at all. These are paintings, which are then wrapped around a box. It's an important point that Jo makes: only when one returns the schema to 3-D (folding the card model bird, or viewing the painted boxes) do the elements join up, allowing the bird to (re)emerge, like an odd perched simulacra.

There is something of Lacan's 'doubling' here: an empirical reality split off from a symbolic meaningful impossibility, a particular bird and a derived colour, the Real that resides in the Illusion. This 'doubling' is dependent on the diversity of the world being reduced to a uniform schema. One fixed dimension of box represents innumerable variations of bird – just as, in a Darwinian sense, we are all variations, in terms of pigment, size and shape, of one basic human form. You can extend this further, adding a post-Darwinian twist by acknowledging that accident is part (the better part?) of 'design', whether that accident is colour in birds, or I would even go as far as to bring in a point Zizek discusses here, how consciousness itself is a kind of mistake, a 'malfunction of evolution'. From this 'error' almost everything that we value, everything that gives life meaning, could be said to originate. These are some of the ideas the colours suggest to me now.

IP: You mentioned the issue of the contemporary multicultural city; the birds, with their simplified colour palette, seem to suggest an almost graspable nomenclature, a relationship being set up between them. There's an implied anthropology, is that your concern?

AF: I avoided conclusions. There is something cultish in the vibrant abstract patterns of the birds. They suggest a symbolic message, though we see that they are strange to us. The work echoes an anthropological approach in the way the schema establish a standard of comparison, but the birds are so greedy for their own colours, so full of themselves, that they refuse interpretation. A peewit beside a macaw: beautiful, so what!

Consider a contemporary work like Gormley's casts: I always felt these people 'moulds' lack a sense of an inner life, consciousness. This is what truly animates us, what we fall in love with, what we see out of. If one is wedded to forms for their own sake then you end up with a bleak domain, an art which elides the 'mistake' of 'consciousness'.

The nest-box form is an abstraction, but even if it does involve an anthropomorphic leap of the imagination, the colours are so madly vibrant that they are bound to carry us beyond the normalising status of the box; beyond the plumage and the shape of wings; beyond the puzzle of 'name that bird'; the colours themselves are so alive. Colour is an animating force: *love* – let's not bother with quote marks round that either. And with the nest-boxes the process of animation goes that crucial step further. The birds themselves make the form into a home. That completes the work.

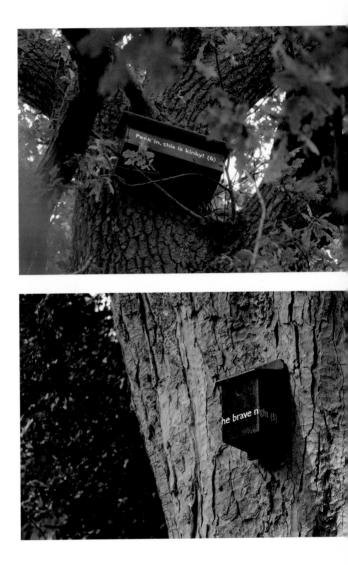

My friend Maris collaborated on a short film[4] of one of the *Field-Guide* nest-boxes, with a blue tit flying into a box and re-emerging, feeding its young. The tit couldn't care less about my painted crossword clue, just as the birds of Liverpool won't give two hoots for the colours of the boxes, but the way these works of art can have a fluttering wee heart alive inside it is great.

IP: Yes, it's a lovely point that they just won't care about the colours – we really do imbue a lot upon them. The boxes are essentially pragmatic objects; homes. But they do become mystified through their symbolism.

In a sense this is where we can separate two of the strands that this work plays with; firstly in art historical and Christian symbolism the bird was commonly used to represent man's desire to be closer to God, to be free of human constraint. They were given fairly high status and the notion arose that we should aspire to achieve the same 'Godliness'. As subject matter the birds evoke a universal sense of desire to transcend, spiritually.

AF: The utopian vision, that sense of flight, but also of sight, of seeing from on high; a sense of looking from present out over past and future. Also seeing landscapes, worlds, but not recognising borders.

IP: Exactly, on the other hand the work has much more rooted associations: with travel and human migration; transgression of geographic boundaries; a relationship with systems of classification of species (Darwin and Audubon's, or Jones and Pinker). These ideas can all be related to issues of control – the type of control enforced by recognition of race, identity, religion. It can't be avoided. You're making work for a multicultural city which has, like so many British port cities, a history of access and travel and, by extension, a history of contested borders, invasion, occupation and slavery. One account attributes the 'Liver' in Liverpool as being a corruption of the name given to this place by the native Ancient Britons (Welsh speakers). In the 13th Century the port of Liverpool was used for the conquest of Ireland by King John who granted letter patent to the town, from which it adopted a seal. The seal included the eagle of St. John, which had made its way onto the King's livery from ancient Greek mythology. The story goes that at a later date, with the original seal having been lost, it was an artist's (perhaps incompetent) adaptation of the eagle that gave rise to what is now recognised as the Liver Bird.

AF: And what the artist does best he or she often does without intention – does by being, in a way, 'useless', without predetermined purpose. That is our job.

IP: ...In a sense, the crest has an equally tenuous relationship with its 'home' country as those on the stamps. Both have suffered – or is that enjoyed? – transformations due to artistic license. Specimen Colony *is a site-specific work which has a direct relationship to the city and the trees in front of the gallery; yet the work is also happily subversive – what I think you mean by purposeless? – being a gift to be discovered by the curious passer-by who cares to look up, or who is intrigued by the activity of the birds who nest there. This act of placing something somewhere, often out in the elements, sometimes hidden – in a forest, on a hillside, on Rannoch Moor, or in a tree in Bad Homburg – and then walking away is something that recurs within your work.*

AF: I suppose that's true. I hope it is a kind of faith in the world and the idea of an encounter. It makes me think of the walks I used to take as a kid – not so far… just over a couple of fields to a burn hidden in a glen, and this little burn was always like a secret. There was always this moment when you walked up to the lip of the glen and you didn't know what you would see – you might catch sight of a heron, or a buzzard. Maybe that's one ideal of art for me?

It could be that in walking away I am also walking towards? Hoping to charm other similar encounters in my own world?

Of course, I grew up around a place where art was very precisely located, in a garden – one in which art was predominant in a way it isn't almost anywhere else that I can think of. Even if you go to Münster to see the *Sculpture Project*, or visit *Documenta*, the actual presence of art in the city seems so minimal, almost paltry, don't you think? The larger art gets, the less it actually seems to affect the world. But with smaller pieces you feel, paradoxically, that the whole world could become art, that we could all share in that process.

To date I have mostly concentrated on making works that have a lightness, an everydayness; they feel like you could encounter them anywhere. The status of artwork is less important to me than this experience of encounter. A haiku does the job as well as anything. Certainly better than most large works of art.

The 'sculptures' I admire more than any are, or were, Hans Waanders' 'perches'; a few sticks stuck in a riverbank for a kingfisher to perch on. They were fragile and are all long gone, but everyone who knew Hans is always living with the same equation: encounter = river = possible kingfisher (= memory of Hans). In comparison to perches, the nest-boxes are almost over-determined, but then there has to be a place for painting somewhere!

IP: That 'lightness' and 'everydayness' relates to much of what you produce; miniature objects, short written works, poems, haiku, circle forms; even your publications, such as pocketbooks; they are all a very modest and 'natural' scale. They are comfortably consumable... each feels ergonomically efficient and correct. There's a Swedish word, which doesn't have an exact English translation, 'lagom'. It means just enough, sufficient but without scarcity or abstinence.

AF: That is true and I think it reflects the odd jumble of modesty and an ambition to turn the whole world into an encounter with art. It's not that I eschew scale as such. The issue is more the relative paucity of 'art' – especially of outdoor sculpture – in terms of the scale of landscape, or a cityscape. That might seem like an odd thing for me to say, given I grew up with my parents' garden [Little Sparta], but that was always more like a series of small outdoor rooms, hedged around with trees and planting. The larger park-like works only came later, once the trees had grown up. I never enjoyed them as much as the 'interior' spaces of the woodland garden, some of which are as small as a few feet across. I may be seeking the same intimacy in the way that the nest-boxes cluster around the heart of each tree.

Anyway, I've always preferred a microtonal approach to landscape, small things, scattered, that connect up in your imagination. Better to see a glacier as art (art-and-nature) than try and make one. In the same way, the more you read haiku the more you become aware of them as atoms of meaning – they expand exponentially in your mind. Scale isn't a matter of *scale*, it's a matter of *imagination*.

I'm not saying I won't make large works one day. After all, the windmill turbine project that I am working on now combines colour, poetry and form in motion and if – I want to say when – these are realised they are *not* small! But these are more like John Latham's model: I'm thinking of his 'Niddrie Woman' project for shale bings in West Lothian; declaring an existing object as sculpture, at the same time as letting them be just what they are.

IP: As with many readymades there's a sense of functionality; in the same way, whether it's a badge or a postcard, the multiples you make are particularly good for sharing, something you often do by mailing them to people.

AF: You're right, there is that tendency in my work – perhaps rather than defining it in terms of scale it could be thought of in terms of the 'gift'? An aspect of my practice falls between sketch, proposal and gift, for instance, the small rubber stamps (circle poem prints), woven poems (embroidered name tapes, sewn onto handkerchiefs) or mesostic plant labels; they all have the status of gifts. I do give them away, or they are sold cheaply and other people give them away. They don't fit into a conventional art economy, not yet anyway.

I have always been fascinated by how things circulate. To begin with it was the postal service, which was so important growing up in the country; and then books; but now it's more personal transactions – sewing a name tape into someone's clothes or sending someone a rubber stamp printed onto a card. These things are part of my practice, like sketching, but as a 'figure of outwardness', to paraphrase Charles Olson – the process is no longer private.

In another way, these pieces or actions – *publicactions* – belong in the tradition of small press poetry, where the thing itself is more suited to being given to someone than sold in a bookshop. I've been thinking recently what a beautiful gesture it was when the poet Bill Griffiths dedicated his last collection to *the little presses*; it reminded me of my allegiance to that world.

I also think that there is a way of considering the kind of publications that Thomas A. Clark, Ian Hamilton Finlay or David Bellingham produce not just in terms of the circulation of ideas, but also in the specific sense of a proposal. This book, and even more so the free card cut-out nest-boxes that we are giving away from my website are proposals. They make clear that anyone can take part and, as gifts, they also pass the work on, inviting people to continue the project (even if the project is just a walk).

IP: There's a real democracy in sharing the works by making them available as downloads. But there's also a simple beauty in the postal system as a means of distribution. The postage stamp collages shift the work into the context of mail art.

AF: Postage stamps are a much grander enterprise in terms of circulation. I'm not sure that reference to them makes the project 'mail art' – maybe it's just suggestive of the way that we all associate stamps with gifts and the now incredibly old fashioned tradition of correspondence, the letter (if anyone remembers what one of those feels like).

Of the various other projects, the collages are the closest to the nest-boxes. They enact the same process of taking a found bird and then juxtaposing it with others, but they were made in an even more intuitive fashion and they tend to meld the birds into odd grafts or hybrids.

IP: I remember seeing the collages for the first time – you had been playing around with the elements in your studio – and I was surprised by them because they felt really instant, like little sketches. I realise they're an offshoot of your process of development – but they do still feel considered and complete. How did they come about?

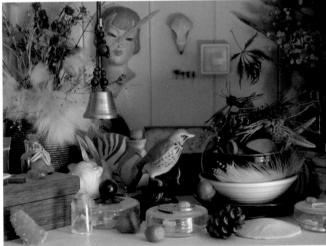

AF: When I was sorting through the thousands of stamps that I purchased, in order to select the final thirty-four birds for the colonies, I had to make some kind of order. I started with countries and species (all the stamps from Kenya; all the owls; and so on). Then I noticed the different styles of postmark that appear on some stamps. These define authenticity for some collectors – again, that idea of how a thing circulates, how that process is authorised, monitored or controlled, like the rather crude heaviness of the wavy USA postmarks – but, because I was focused on the bird itself, rather than the political status of the stamps, the postmarks were just another layer of printing.

Their flaws became a sign of identity, as if they gave each bird an individual character. Without really intending anything, I began to play with the different styles of stamp or frank, matching different sized circles, lines and waves. The compositional process, matching lines to connect stamps, was purely formal. I didn't care which country a stamp was from or what bird was featured. The end results produce a series of odd, randomly generated juxtapositions of bird species, and these are like a colony (hence the stamp that I overprint over each finished collage).

IP: *The combination of elements, the angles they're set at, and the slightly messy printing, creates an eerie nostalgia … they remind me of Schwitters, very vibrant and dynamic.*

AF: Yes, that is what I enjoyed most about making them; the way that they draw one's attention to a very delicate Schwittersesque quality, poetic and flawed, the details of black overprintings. There is a section in Walter Benjamin's *One-Way Street* ('Stamp Shop') where he refers to postmarks as the 'occult part of the stamp', its 'dark side', for the way the marks can change the meaning of a stamp by violating it. The postmarks seem to 'age' the stamps. This work is more personal, more private compared to the nest-boxes – like you said, a kind of sketch, distinct from the public status of the nest-boxes. I can't help noticing that many of them make pairs, odd but balanced relationships, so maybe that says something about me?

IP: *And then there are the* blackbirds, *which are related to the collages, as a similar by-product of process. I like the obvious pun that arises from their title.*

AF: If I remember right, they arose shortly after the collages. Again, it came from playing with all the stamps. Another category was 'flying birds', which there are few enough of to make them seem special – surprisingly, given it's what we think of birds as doing. I made one of these 'fliers' into a silhouette by inking the bird in. The black reverses the love of colour in the nest-boxes. It has an odd de-centering effect on the stamp design, creating a flat void in the centre, where the bird should be.

Blackbirds are a kind of *via negativa*; it's no coincidence that they were the first work that I made after my father died, in the spring of 2007. I had just moved into a new studio and the task of inking in tiny birds with a Rotring pen for hours on end was welcome at the time. Mind you, I needed to get glasses as a result.

IP: *The 'blacking out' of the subject is a technique that's been used by a number of artists often to indicate loss, or a desire to remove a subject from context. I think with your birds it works well because there's lots going on, despite their simplicity; especially with those which are presented in their perforated geometric blocks, it persuades you to see the images as a series, like a film strip or an Eadweard Muybridge photographic study illustrating the gait of horses. You automatically read movement into them. And you're right, there's a flattening effect, so the birds become black amorphous forms that transform as they flutter across the page.*

Normally we'd use colour to identify bird species, age and sex, or whether they have summer or winter plumage ... you've removed that entirely, leaving us with just the silhouette. These birds become nonsequiturs; we can't easily resolve them as we normally would.

AF: I didn't make the connection at the time, but Hans [Waanders] had also made some black silhouette kingfisher pieces. More consciously in my mind was a series of found bookworks that he made using rubber stamp overprinting. He collected bird field-guides at flea markets and then carefully overprinted every illustrated bird (except the kingfisher) with one of his rubber stamp kingfisher motifs – a kind of careful yet obsessive marking of territory. I have three of his beautiful *Field-Guides* in my library.

Another fellow traveller to the *blackbirds* is Tacita Dean's postcard interventions, especially the series of tree works, where she whites out the entire surroundings. I didn't know these until recently and I think they have a more 'floating world' Oriental feel, because the white is so like mist, but there is a romantic quality that they share with the *blackbirds*.

Tacita's and Hans' journeys, made within their physical limitations, show a willingness to give oneself to a quest, trusting it will enact a magical discovery. *Specimen Colony* doesn't elaborate any particular journey. I did consider mailing the bird stamps to or from various countries, to make them authentic (rather as Eugenio Dittborn does with his Airmail paintings) and echo the process of migration; but in the end the work is not about any specific journey that I (or anyone else) made.

IP: I want to mention the text works that seem to be an extension of the Specimen Colony *stamp. Although they're not entirely separate, they definitely have their own form.*

AF: These relate to the circle poems that I have made for the past five or six years. The designs are borrowed from a survey book, *Postmarks of the World*. Imagine, there are people who collect such things! Some of the circle poems refer to twitching and birding – for instance, unfolding a beautiful word, such as 'pelagic' – and others refer to stamp collecting – quoting terms such as 'topic', which relates to the different themes of stamp image that some collectors specialise in. A few of the circle poems are just minimal or aphoristic pieces that seemed appropriate.

IP: And the longer poem, 'The Recognisable Bird'? It has a peculiar mix of voices; a description of the works, the rules that were constructed as work progressed, Jo's thoughts and comments and your ideas.

AF: It's certainly an odd hybrid form that still surprises me. I've composed four collaborative pieces in this style recently: (*Journey to the Lower World*, with Marcus Coates; *siren*, with Chris Watson; and *two fields of wheat seeded with a poppy-poem*, with an ensemble of collaborators). They use quotations from correspondence, which I then edit and lineate. In the narrative for *Specimen Colony* the words are mostly taken from Jo Salter's quirky notes which he sent along with each new design. His emails were so insightful, I felt we had to use them in some way; so I edited them all down and worked them into this three line form. The way the line endings fall is a useful container for Jo's wit. The piece is commentary by means of a humorous series of mini-excursions around the work, not a sober and methodical explication. It allows the reader to enjoy Jo's voice, and he knows much more about the individual birds than I do.

IP: Finally, I want to ask you about the photographs of the ceramic bird ornaments. These for me are an estranged part of this body of work, but they bring to it a more human element, less scientific than that of the ornithologist or philatelist.

AF: *Birdhouse* predates *Specimen Colony*. I made it 2 or 3 years ago. The bird figurines were painted black-and-white – again the removal of colour – to translate them into vignettes. The original inspiration was a piece of Marcus Coates' that I am very fond of, a stuffed hawk which he repainted in the plumage of a starling. Then I invited Alexander and Susan Maris to photograph the five birds in their mother's rather 'perjink' home in Scotland. There is a nod to some of the photographs of ornaments in the tower block in Liverpool that Marcus included in *Journey to the Lower World*. There will also be an indoor sculpture that I am making for the Bluecoat restaurant-bar (a cast cormorant with outstretched wings, referring to the origins of the Liver Bird), and in this case the bird is an exact replica, right down to the seaweed in his beak.

Birdhouse and *Field-Guide* are ongoing projects in their own right, but they suggest a wider context for *Specimen Colony*, both in terms of my own work and that of friends such as Hans Waanders, The Maris and Marcus.

IP: In a way, by creating these multiple outcomes what we see is never the final finished object; each incarnation is a 'phantom' (to use a philatelic term) which refers to an 'other', some non-existent original.

AF: Which is exactly the point at which one hands it over to the reader.

Iain Pate & Alec Finlay

Note

[1] *This work was conceived at the time of the invasion of Afghanistan.*

[2] *During the Duvalier dictatorship a number of forged Haitian postage stamps were produced, including some Audubon bird illustrations. These are generally frowned on by stamp collectors.*

[3] *Audubon is another connection with Liverpool; he stayed in the city in 1826, and was supported by the patronage of Richard Rathbone, a wealthy cotton merchant and future mayor.*

[4] Amid the brave night (5); *a short video, viewable on* www.alecfinlay.com

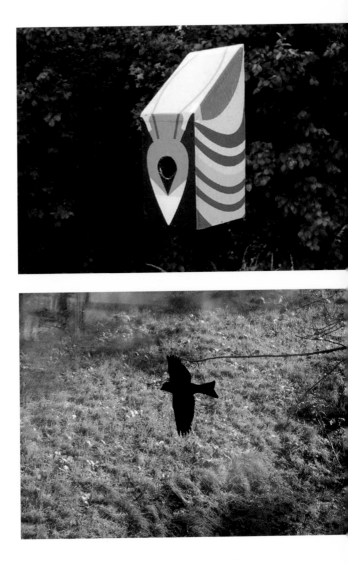

Bibliography

The Observer's Book of Postage Stamps, Anthony S. B. New (Frederick Warne, 1967)

Collect Birds on Stamps, (Stanley Gibbons, 5th Edition, 2003, revised by Dr. Malcolm Ogilvie)

Collecting Bird Stamps, Christine E. Jackson (H. F. & G. Witherby, 1977)

World Postmarks, R. K. Forster (Batsford, 1973)

Imagined Lands: Postage Stamps for an Imagined Scottish Republic, Alec Finlay (ed),
(City Art Centre, Edinburgh, 1996)

The World of Donald Evans, William Eisenhart (Harlin Quist, 1980)

RSPB Complete Birds of Britain and Europe, Rob Hume (Penguin, 2002)

John James Audubon: The Making of an American, Richard Rhodes (Alfred A. Knopf, 2004)

Field-Guide, Hans Waanders (various, self-published by the artist)

Analogue, Tacita Dean (Steidl, 2006)

Mapa: Airmail Paintings, Eugenio Dittborn, (ICA, 1993)

One-Way Street, Walter Benjamin, translated by Edmund Jephcott & Kingsley Shorter (NLB, 1979)

www.bird-stamps.org

Photographs

1. *Liver Bird, the Bluecoat*, (2007)

2. *Letterbox*, Alec Finlay; located on the Isle of Thanet, photograph by Paul Hazelton, (2005)

3. *Field-Guide (Dysart):* Alec Finlay, photograph by Alexander Maris, (2007)

4. *Field-Guide (Milton Keynes):* Alec Finlay, photograph by Alexander Maris, (2007)

5. *Birdhouse*, Alec Finlay, with Alexander & Susan Maris, (2006)

6. *Birdhouse*, Alec Finlay, with Alexander & Susan Maris, (2006)

7. *Nest-box (Greenfinch)*, Alec Finlay & Jo Salter, for *Hidden Worlds*, Windmill Community
 Garden, Nottingham, photograph by Jo Salter, (2006)

8. *Silhouette (crow)*, Alec Finlay, photograph by Alex Hodby, Yorkshire Sculpture Park, (2005)

SPECIMEN COLONY (POSTMARK COLLAGES)
Alec Finlay

SPECIMENS (POSTCARDS)
Alec Finlay

BLACKBIRDS
Alec Finlay

SPECIMEN
COLONY

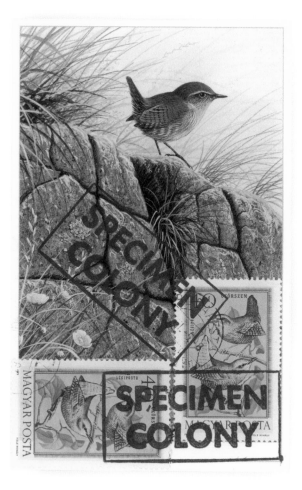

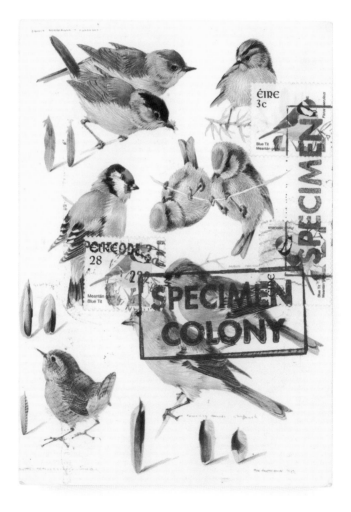

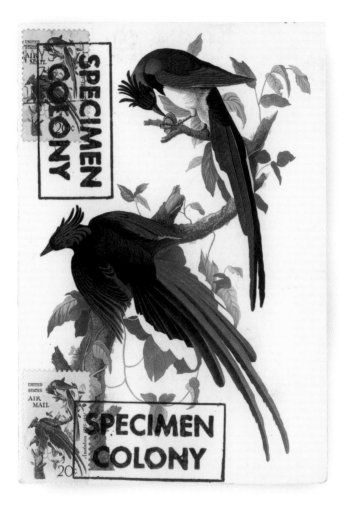

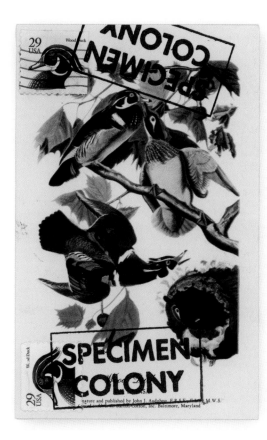

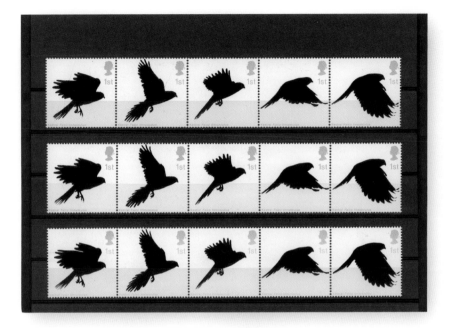

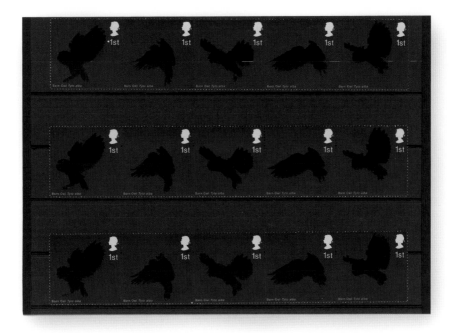

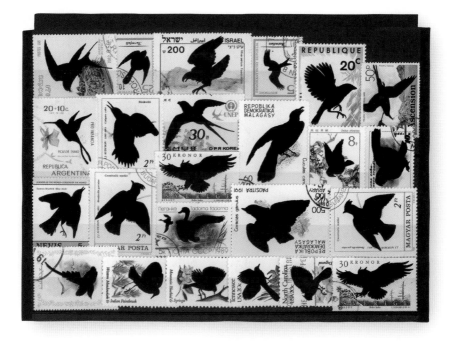

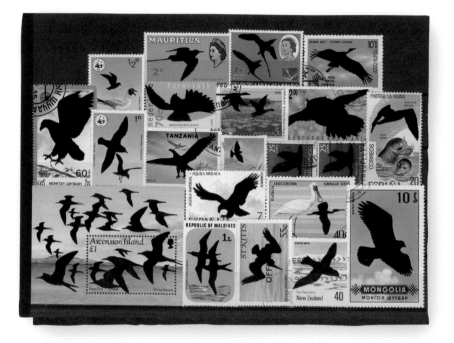

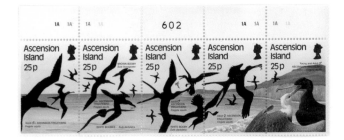

POSTMARK POEMS

Alec Finlay

BIRD POEMS

Alec Finlay

MESOSTIC ORNITHOLOGIA

Alec Finlay

JUKEBOX

Bryan Biggs

fallen flown
flown fallen

lumpers combine
splitters divide

we all have an island name we all have an island name

passerine
passer-by
pelagic
oceanic

distinguish an order
attributes
attributes
distinguish an order

we face the sea with our backs to the shore

waders
birders ringers

the sky is a mirror the sky is a mirror the sky is a mirror

rain calls
songs call songs fall
songs fall
rain falls

folded in
turned over
opened up

following one goose leading a skein of geese

BIRD POEMS

for Marcus Coates

I

We know their songs
before we learn their names.

Still in the trees there is birdsong,
the evening light forgives.

II

The ducks sleep
with their heads
turned around.

The duck's curl
is a rudder.

III

Seagull prints
point to the sea.

Her hands are birds,
the blades of her shoulders
open pelagic.

IV

Yellow cups, oyster catchers,
a fuss goes up in the set aside.

The tractor pulls
a wheeling flock.

MESOSTIC ORNITHOLOGIA

poems composed on the names of birds

Booms
rIng
ouT
Through
thE
daRk
Night

Botaurus stellaris

streaKing
hIs
burNished
plumaGe
Fast
glInting
colourS
tHat
sharpEn
memoRy

Alcedo attis

darK
silhouEttes
Swoop
To
eaRth
likE
Lightning

Falco tinnunculus

suCh
daRk
moOdy
scoWls

Corvus corone

tHe
stillEst
fisheR
Of
dawN

Ardea cinera

Some
sKillful
harmonY
Lifts
An
azuRe
sKy

Alauda arvensis

The
eyEs
shaRp
Need

Sterna dougallii

Foul
pUking
guLls
Make
A
Reek

Fulmarus glacialis

JUKEBOX
Bryan Biggs

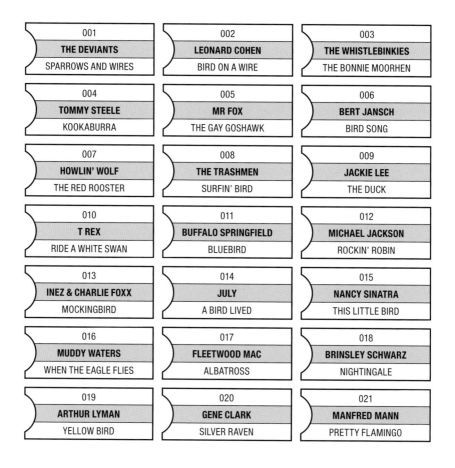

001	002	003
THE DEVIANTS	**LEONARD COHEN**	**THE WHISTLEBINKIES**
SPARROWS AND WIRES	BIRD ON A WIRE	THE BONNIE MOORHEN
004	005	006
TOMMY STEELE	**MR FOX**	**BERT JANSCH**
KOOKABURRA	THE GAY GOSHAWK	BIRD SONG
007	008	009
HOWLIN' WOLF	**THE TRASHMEN**	**JACKIE LEE**
THE RED ROOSTER	SURFIN' BIRD	THE DUCK
010	011	012
T REX	**BUFFALO SPRINGFIELD**	**MICHAEL JACKSON**
RIDE A WHITE SWAN	BLUEBIRD	ROCKIN' ROBIN
013	014	015
INEZ & CHARLIE FOXX	**JULY**	**NANCY SINATRA**
MOCKINGBIRD	A BIRD LIVED	THIS LITTLE BIRD
016	017	018
MUDDY WATERS	**FLEETWOOD MAC**	**BRINSLEY SCHWARZ**
WHEN THE EAGLE FLIES	ALBATROSS	NIGHTINGALE
019	020	021
ARTHUR LYMAN	**GENE CLARK**	**MANFRED MANN**
YELLOW BIRD	SILVER RAVEN	PRETTY FLAMINGO

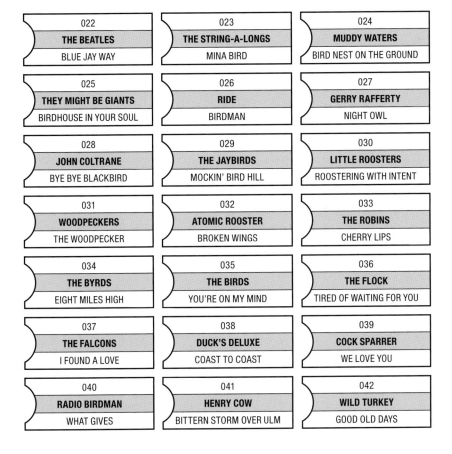

022	023	024
THE BEATLES	**THE STRING-A-LONGS**	**MUDDY WATERS**
BLUE JAY WAY	MINA BIRD	BIRD NEST ON THE GROUND

025	026	027
THEY MIGHT BE GIANTS	**RIDE**	**GERRY RAFFERTY**
BIRDHOUSE IN YOUR SOUL	BIRDMAN	NIGHT OWL

028	029	030
JOHN COLTRANE	**THE JAYBIRDS**	**LITTLE ROOSTERS**
BYE BYE BLACKBIRD	MOCKIN' BIRD HILL	ROOSTERING WITH INTENT

031	032	033
WOODPECKERS	**ATOMIC ROOSTER**	**THE ROBINS**
THE WOODPECKER	BROKEN WINGS	CHERRY LIPS

034	035	036
THE BYRDS	**THE BIRDS**	**THE FLOCK**
EIGHT MILES HIGH	YOU'RE ON MY MIND	TIRED OF WAITING FOR YOU

037	038	039
THE FALCONS	**DUCK'S DELUXE**	**COCK SPARRER**
I FOUND A LOVE	COAST TO COAST	WE LOVE YOU

040	041	042
RADIO BIRDMAN	**HENRY COW**	**WILD TURKEY**
WHAT GIVES	BITTERN STORM OVER ULM	GOOD OLD DAYS

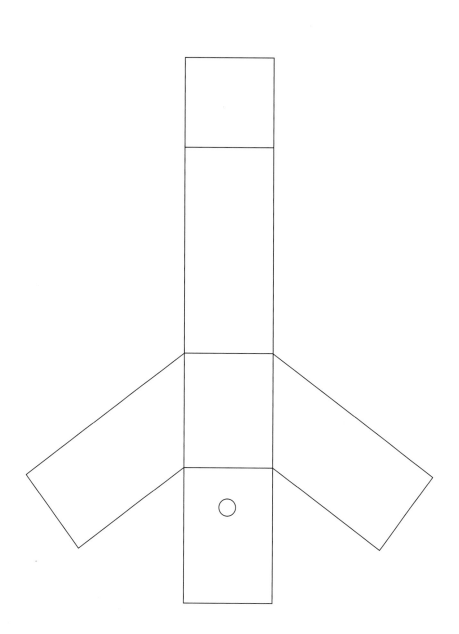

SPECIMEN COLONY CARD CUT-OUTS

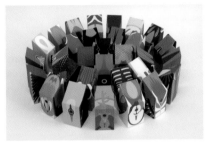

The schema of all thirty-four nest-boxes are available as free card cut-out
models downloadable from www.alecfinlay.com and www.thebluecoat.org.uk

A blank schema is also available, on which you can design
your own real or imaginary bird.

AUTHOR NOTES

ALEC FINLAY

Artist, poet and publisher, born in Scotland; lives in Newcastle Upon Tyne. Recent exhibitions include two fields of wheat (Milton Keynes Gallery) and Waterlog *(Film and Video Umbrella, Sainsbury Centre for Visual Art, Norwich). Publications include the* pocketbooks *series (1999–2002) and, more recently,* what changes change *(Redfox, 2007), and* Mesostic Laboratorium (platform projects, 2007). *Finlay pioneered the revival of the Japanese collaborative poetry form renga in the UK (www.renga-platform.co.uk). He is currently working on a* 100 Year Star-Diary *for a new observatory at Kielder, and a major project devising colour schemes for windmill turbines, in collaboration with Jo Salter.*

ALEXANDER MARIS

Alexander & Susan Maris describe themselves as 'Post Urban' artists, and have been collaborating as such since 1990. They are currently working on a digitally archived reforestation project for Rannoch Moor, which anticipates the eventual reintroduction of the European Wolf, Lynx and Black Bear into the Scottish Highlands.

ANDREW MORLEY

Artist and writer, born Nottingham; lives in Newcastle Upon Tyne. Since 1970 Morley has produced a continuing series of montage / collage works, Temples of Nostalgia, *and an ongoing series of sketchbooks featuring musicians during performance. He has co-authored a series of five books on the history of enamel advertising signs since 1978, the most recent being* The Art of Street Jewellery *(New Cavendish Books, 2006).*

IAIN PATE

Iain Pate is currently Programme Manager at Forma Arts & Media, a creative producing agency that specialises in touring and presenting inter-disciplinary art around the world. Iain also works as an independent curator with an interest in temporary works sited in public locations. He graduated from Gray's School of Art in 1998 and has co-curated exhibitions including Berwick Film & Media Arts Festival 2007 and Revisiting Home at NGBK, Berlin in 2005. Iain previously worked with Dundee Contemporary Arts, Dundee, Esther Schipper, Berlin and La Panaderia, Mexico City.

JO SALTER

Born in Glasgow. A graduate in Fine Art from Gray's School of Art (Aberdeen), Salter is a painter who also works as a graphic designer and community & environmental artist. For many years he lived and worked in the Western Isles where he was a Director of Taigh Chearsabhagh Arts Centre. He subsequently curated New St Gallery at Out of the Blue *(Edinburgh). He currently teaches art in a secondary school in Staveley.*